Digital Shift

Digital Shift

The Cultural Logic of Punctuation

Jeff Scheible

 University of Minnesota Press

Minneapolis

London

A version of chapter 2 was previously published as "Within, Aside, and Too Much: On Parentheticality across Media," *American Literature* 85, no. 4 (Winter 2013): 689–717, copyright 2013, republished by permission of the publisher, Duke University Press, www.dukeupress.edu. A portion of chapter 3 originally appeared in "Longing to Connect: Cinema's Year of OS Romance," *Film Quarterly* 68, no. 1 (Fall 2014): 22–31, copyright 2014 by The Regents of the University of California; all rights reserved.

Published by the University of Minnesota Press
111 Third Avenue South, Suite 290
Minneapolis, MN 55401–2520
http://www.upress.umn.edu

Library of Congress Cataloging-in-Publication Data
Scheible, Jeff.
Digital shift : the cultural logic of punctuation / Jeff Scheible.
Includes bibliographical references and index.
ISBN 978-0-8166-9573-7 (hc : alk. paper)
ISBN 978-0-8166-9574-4 (pb : alk. paper)
1. Mass media—Technological innovations. 2. Mass media—Social aspects. 3. Mass media and culture. I. Title.
P96.T42S34 2015
411—dc23

2014028191

Printed in the United States of America on acid-free paper

The University of Minnesota is an equal-opportunity educator and employer.

21 20 19 18 17 16 15 10 9 8 7 6 5 4 3 2 1

Contents

Acknowledgments

One of the more exciting aspects of writing this book is that it prompted many people who heard about it to send resources, ideas, and anecdotes related to punctuation from popular culture to media theory my way. Research and writing have in this sense felt rewardingly collaborative. I am indebted to the many friends, colleagues, and mentors I was privileged to meet at UC Santa Barbara. Edward Branigan, Nicole Starosielski, and Dan Reynolds have generously given their time and thought to read drafts of this manuscript and offer incisive, inspiring feedback. Constance Penley, Janet Walker, and Alan Liu have been smart, challenging, and supportive readers of my work, too. Other friends, readers, and teachers who have helped shape this project include Joshua Neves, Bishnupriya Ghosh, Bhaskar Sarkar, Lisa Parks, Peter Bloom, Charles Wolfe, Regina Longo, Megan Fernandes, Rita Raley, Allison Schifani, Kevin Kearney, Athena Tan, Meredith Bak, Chris Dzialo, Rahul Mukherjee, Maria Corrigan, Anastasia Hill, and Hye Jean Chung.

My interest in punctuation emerged during my years working as a copy editor, then managing editor, of *Camera Obscura*. My rotating tasks included printing drafts of articles, marking them up with grammatical and spelling corrections, and writing editorial inquiries to authors. The marks I made often used punctuation as shorthand, suggesting ways in which these typographical symbols are

semiotic codes we use to facilitate communication and consolidate complex commands. On other occasions my marks more literally corrected punctuation usages—adding em dashes where authors did not know they belonged, inserting parenthetical page references, shortening sentences by substituting semicolons with periods, and so on. I developed a sensitivity to the topic of punctuation by working with writing on such a detail-oriented level. It is natural to overlook punctuation, but the more time I spent editing, the more I became intrigued by the ways it structures our thought and can open out onto thinking about not only language but about history, habits, personalities, style, visual culture, graphic design, rules, and, perhaps most appealing to me, breaking rules. I worked closely with many people I admire while there: Constance Penley, Patricia White, Amelie Hastie, Lynne Joyrich, Sharon Willis, Andrea Fontenot, Athena Tan, and Ryan Bowles.

A wider community of colleagues and audiences has given feedback to drafts of chapters and conference presentations that has directly and indirectly worked its way into the following pages. Thanks to Wendy Chun, Patricia White, James Hodge, Zach Meltzer, Brian Jacobson, and engaged audiences at UCSB, Concordia University, SUNY Purchase, University of Aberdeen, University of Chicago, SCMS meetings in Seattle and New Orleans, and the Visible Evidence XX Conference in Stockholm. Thanks also to Mara Mills for putting me in touch with George Kupczak from the AT&T Archives and to George for sharing Bell Labs documents with me. My relatively speedy completion of this manuscript would not have been possible without a generous Banting Postdoctoral Fellowship that granted me research time in Concordia University's Mel Hoppenheim School of Cinema, which Martin Lefebvre and Haidee Wasson were instrumental in helping me secure. While there, Juan Llamas-Rodriguez offered excellent research assistance in final stages. My writing in Montreal was bolstered by a new community of scholars and friends, including Tom Waugh, Marc Steinberg, Yuriko Furuhata, Michelle Cho, Luca Caminati, Masha Salazkina, and Katie Russell. Jocelyn Braddock, Matt Kaelin, Marc Boucai, Amy Robinson, the Blocks, Mathieu

Leroux, and Sally Heller have offered perspective, stimulation, distractions, and care when they were needed.

It has been a pleasure to work with University of Minnesota Press, and I of course am also indebted to Danielle Kasprzak and the anonymous readers for the Press, who offered valuable feedback.

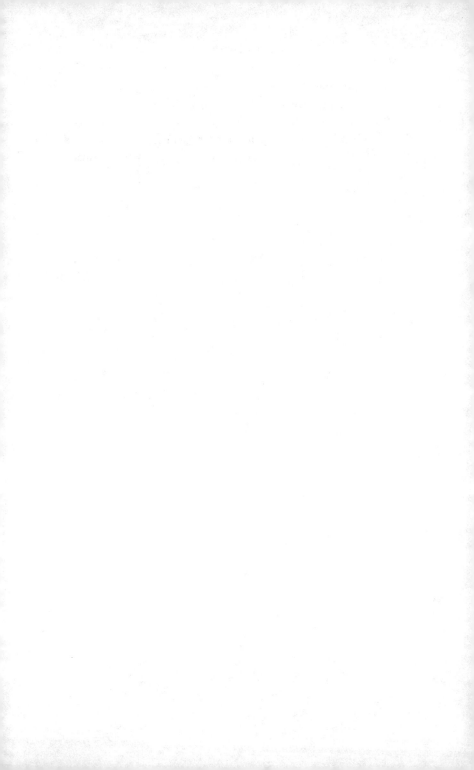

Introduction

Textual Shift and the Cultural Logic of Punctuation

The Equal Sign Takes Over Facebook

Every day in 2013, over a million Facebook users in the United States updated their profile pictures. On March 26, 2013, however, 2.7 million (120 percent) more users than usual changed them. The overwhelming majority of the new images that accounted for this spike were variations of the same basic design: a pink equal sign on a red backdrop. This trend was due to the Human Rights Campaign's (HRC's) newly colored logo (now red and pink rather than their previous blue-and-yellow equal sign) to support marriage equality for homosexual Americans in the context of the Supreme Court's hearing cases that week regarding California's Proposition 8 and the Defense of Marriage Act, legislation that denied rights to gays in the United States. This swarm of pink and red pictures of symbols in squares represents a distinctly digital form of media activism whose usefulness and meanings are probably less obvious and more complicated than we might think at first. Like all popular Internet phenomena, this image generated a wave of responses and variations: from a pink "greater than" sign replacing the equal sign as a queer critique of heteronormativity by the activist organization Against Equality to an image of television's Southern cooking icon Paula Deen edited sitting atop the image, with text reading "It's like two sticks of butter, y'all." Nearly all popular news

websites in the week following the phenomenon compiled slide shows of their favorite variations.

Texts, as humanists know, exist in contexts. What might we discern about the context of this visual text, a pink equal sign in a red square, that millions of people adopted as their online avatar? How do we understand the significance of its politics? How does it relate to the Supreme Court hearings that occurred in conjunction with it? What picture does this image of the equal sign paint of American media and society in our digital twenty-first century? In what set of conditions does it make sense as a cultural phenomenon?

While the flood of pictures generated some expected criticism of the effort for having few practical political consequences—a critique

Figures 1a, 1b, 1c, 1d. HRC's Facebook equal sign profile pictures and variations

lodged in terms for phenomena to which this could be said to belong, like slacktivism or clicktivism—the unprecedented number of changes made visible the massive public support for marriage equality. It undoubtedly serves as a strong visual statement about the popularity of the cause of gay rights among mainstream sentiments. In response to the mass picture change, an article published on the blog of Visual AIDS suggests,

> Photoshop activism may seem like a silly thing, creating an image, being part of a picture-based conversation. But one of the numerous lessons we can gleam [sic] from ongoing AIDS activism, is that expression matters. It is not the be all and end all, but art helps interrupt a conversation, create new ways of thinking, provides a way to heal while acting up, and broadcasts dissent when words are not enough.[1]

The authors also quote Djuna Barnes: "An image is a stop the mind makes between uncertainties."[2]

Between these and indeed probably other uncertainties, it is easy to take the contemporary phenomenon of the mass picture change for granted and as obvious, but what if we reflect on it as strange and unnatural, as if we are historians or cultural critics from the future looking back or societies of the past looking forward: How did we get here? I would like to pause, then, on something that not many observers have discussed in relation to this widely circulated and altered image: its actual content. It contains one simple typographical mark: an equal sign.

The equal sign, while not technically punctuation, is nevertheless like punctuation in that it is a single typographical mark that helps us make sense of the relationship between the two terms it comes between. It is what we might think of as *loose* punctuation as opposed to *strict* punctuation. In the digital mediascape, traditional conceptualizations of the parameters of punctuation as a category of typographic symbols no longer seem adequate to characterize the range of signification practices at play in textual exchanges. As I will argue more extensively at the end of this book in relation to the hashtag, identifying such a mark as punctuation, when it has not traditionally been used in writing as punctuation,

productively alerts us to shifts in the ways language and image relate to each other via contemporary textual practices. Perhaps the most illustrative and familiar example of this is writing emoticons, where iconic compositions of punctuation integrated within textual exchanges call attention to new configurations and alliances between language and image within social practices, mirroring and standing in for a broader shift that has occurred with the emergence of digital media cultures. To understand how we have arrived here, for now we can think of loose punctuation like the equal sign and strict punctuation like the period and parenthesis together as belonging to a larger set of typographical marks that function with other typographical marks and units of language to signal a set of semantic and aesthetic relations. If not yet, hopefully by the end of this book, my readers will be comfortable with this expansive view of punctuation, convinced of this shift and how it helps us understand media, textuality, and aesthetics in the digital age.

Since its emergence in the mathematical context in which it was introduced in the sixteenth century, the equal sign is supposed to fall between two different terms, indicating that between them there is a relationship of equality, and thus of interchangeability and identicalness. But what does it mean when, here, the symbol stands by and for itself, isolated as a logo for a political media campaign? Furthermore, to what extent does its widespread circulation and reappropriation depend on the text being removed from its general contextual signifying practices and isolated?

Kant usefully implies in his *Prolegomena* that the equal sign is not as neutral as its users might like us to believe. He writes,

> It might at first be thought that the proposition $7 + 5 = 12$ is a mere analytic judgment, following from the concept of seven and five, according to the principle of contradiction. But on closer examination it appears that the concept of the sum of $7 + 5$ contains merely their union in a single number, without its being at all thought what the particular number is that unites them. The concept of twelve is by no means thought by merely thinking of the combination of seven and five; and, analyze this possible sum as we may, we shall not discover twelve in the concept. We must go beyond

these concepts by calling to our aid some intuition corresponding to one of them, i.e., either our five fingers or five points. . . . Hence our concept is really amplified by the proposition 7 + 5 = 12, and we add to the first concept a second one not thought in it. Arithmetical judgments are therefore synthetic, and the more plainly according as we take larger numbers; for in such cases it is clear that, however closely we analyze our concepts without calling intuition to our aid, we can never find the sum by such mere analysis.[3]

In other words, the equal sign does not just neutrally identify a relationship, it serves to make meaning, directing our thought to a relationship of equality between two terms that we do not a priori associate with each other—whether between the ideas of 5 + 7 and 12 or what this image wants to forge an association between, rights to heterosexual marriage and rights to homosexual marriage. To recall a more recent statement about the sign, consider, "2 + 2 = 5 (The Lukewarm)," the opening track of the band Radiohead's 2003 *Hail to the Thief* album. Anticipating the album's thematic focus on dishonesty, the song exposes the symbol's conceit, confronting us with the equal sign's power to signify our false hopes in fact and neutrality directly and effectively by presenting us with an incorrect equation, and hence the sign's construction of meaning.

When the equal sign is isolated and is able to activate political signification processes, it indicates that we are in a particular textual regime, one where inscriptions that are not words are nevertheless able to be semantic, sufficient, and communicative. One specific way to understand this textual condition is in its correspondence to what Naomi Klein describes as the newly emergent role of the logo in the 1980s and companies' "race toward weightlessness," aiming to maximize the circulation of powerful images and minimize the creation of actual material products with its reliance on labor.[4] Klein explains, "This scaling-up of the logo's role has been so dramatic that it has become a change in substance. Over the past decade and a half, logos have grown so dominant that they have essentially transformed the clothing on which they appear into empty carriers for the brands they represent." Referring to high-end apparel company Lacoste's logo, she concludes, "The metaphorical alligator,

in other words, has risen up and swallowed the literal shirt." This shift resonates with Jean Baudrillard's thoughts about postmodernity's secessions of simulacra, where a primary, material realm is subsumed by a secondary, immaterial, image-based economy of exchange.[5]

To my mind, the power and spread of the Human Rights Campaign's modified equal sign logo across the Internet is inseparable from these same issues raised by critiques of capital and discussions of postmodern semiotics, unfashionable as that periodizing category may have become at the current moment. As Ryan Conrad of Against Equality has noted, the campaign for marriage equality has been spearheaded by extremely well-funded nonprofits that are inextricable from the capitalist ideologies of neoliberalism.[6] I will return to this concern with postmodernism as an ongoing inquiry in this book, as I believe that in the context of the digital, the status of postmodernity is productive to interrogate and, contrary to what we might think, it has not been exhaustively explored. To not scrutinize the power of images and their signifying practices across digital culture would be intellectually shortsighted.

In addition to "liking" and "posting," we need to remember that there is an arsenal of strategies available for engaging with contemporary visual culture, including long traditions of aesthetic and semiotic inquiries. Indeed, when Facebook's profile pictures transform into a sea of typographical symbols, is this not an all-too-literal manifestation of our real bodies becoming data bodies? On some level, does this sea change not ironically indicate that our selves are interchangeable with interchangeability itself? To answer in the affirmative with conviction, it is useful to imagine an alternative scenario. Would it have been possible to substitute the equal sign with an image of two members of the same sex in wedding attire, exchanging vows or kissing, which would then have been adopted by millions of users as their avatar? Or perhaps even more radically, imagine a scenario in which each individual member posts a photo of himself or herself engaged in an act of homosexual love, however he or she interprets the concept. With the equal sign, we must concede that we are algorithmic functions, machine parts of capitalism: data bodies that like, not human bodies that love.

In an age when we are increasingly constituted as data bodies, when our habits and knowledge are shaped by algorithmic functions and equations, typographical symbols to a certain degree have taken on the power to stand in for our selves. Significantly and compellingly, the equal sign could be read as an allegory of what David Golumbia has referred to as the "cultural logic of computation." He writes, "There is little more to understanding computation than comprehending this simple principle: mathematical calculation can be made to stand for propositions that are themselves not mathematical, but must still conform to mathematical rules."[7] Golumbia contends that rather than representing an unprecedented, new historical rupture with previous philosophical traditions as so many writers about "new" media want to have it, computation in fact is an extension, culmination, and utopian realization of rationalism, a mode of thought that has been pursued for centuries. The wide circulation of the equality logo thus presents us with an allegory of our immersion in computationalism, where the desire to rid ourselves of ambiguity represented by mathematical calculation seamlessly extends to the logics of visual culture.

The Cultural Logic of Punctuation

Where Golumbia writes of computation's "cultural logic," in this book, I write about punctuation's "cultural logic," a phrase popularized in critical theory by Fredric Jameson's study of postmodernism, terms that he himself could have used an equal sign in front of when suggesting the substitutability of the terms "postmodernism" and "the cultural logic of late capitalism" in the title of his landmark "Postmodernism, or, The Cultural Logic of Late Capitalism." As Jameson writes there, "I have felt . . . that it was only in the light of some conception of a dominant cultural logic or hegemonic norm that genuine difference could be measured or assessed."[8] Following Jameson's reliance on the phrase's assistance in the identification of difference (a pursuit that critics of Jameson tend to forget is his ultimate interest), I also find *cultural logic* a useful phrase for thinking about how dynamic, structuring, and shared ways of

thinking—both obvious and not obvious—are inscribed in and interact in a single site. My use of the term, however, departs from, if still hopefully resonates with, the more directly Marxist connotations it carries in Jameson's work. I use it more specifically in relation to "punctuation"—and unlike Jameson's "late capitalism" and Columbia's "computation," punctuation as a concept has been around as a seemingly stable category for hundreds of years. Working through punctuation's cultural logic, we will be able to identify how these typographical marks correspond to particular styles of thinking, and how, in the context of the emergence of digital media, the roles of textuality in media culture have undergone a series of shifts. I am not arguing that there have been erosions or eruptions, but I am claiming there have been what one could envision as shifts in balance, in distributions of conceptual weight, in values and valences, in storytelling and communication habits, and in aesthetic and social relationships that changes in the cultural logic of punctuation help us measure. While I am very sympathetic to the resistance of Columbia (and indeed, so many critics, such as Lisa Gitelman and Wendy Chun, to name primary examples) to the rhetoric of digital media's "newness," it is nevertheless equally as easy and problematic to discredit the significance of the profound changes that have accompanied the emergence of the digital. For a variety of reasons, punctuation and nonalphanumeric symbols, as marks that have existed (and changed) for centuries of writing, anchor opportunities to weigh these continuities, shifts, and expansions that can be sensed as occurring with the ongoing popularity of networked computing. By drawing attention to the concept of textual shift, I aim to both map out some significantly distinct textual dynamics of the digital era and to be wary of overstating divides and differences.

The example of the equality sign certainly does not tell the full story of this shift, but it offers a snapshot that sets the stage. Its aesthetics and politics, and its cascading contradictions, put us on a path for thinking more seriously in our contemporary postmillennial context about what Marshall McLuhan sought to explore fifty years ago as "typographic man," a phrase that presciently forecasts the weight of electronic media's textual shifts upon our

consciousness and suggests that they have been tangibly perceptible and in the works for decades.[9] With various textualities proliferating across our media landscape, zeroing in on specific punctuation marks sets in motion an intermedial series of questions about reading protocol and the social-affective dimensions of textual systems. Before we fully pursue this line of thought, a working definition of punctuation, along with a common understanding of its functions, is in order.

While we might be inclined to view punctuation marks as textual units predating language, out there in the world for us to pluck from the air (or more literally from the surfaces of our keyboards and typing pads) as we wish to write, they are not natural. Punctuation marks are invented inscriptions that arose in particular historical contexts, and their meanings have cyclically congealed and fluctuated in a variety of subsequent historical and linguistic contexts. As social inscriptions, they therefore carry with them ideological underpinnings. As stylistic markers, their usages reflect epistemological and aesthetic conditions. This is what Theodor Adorno provocatively observed in his terrific and somewhat uncharacteristic short essay on punctuation: "History has left its residue in punctuation marks, and it is history, far more than meaning or grammatical function, that looks out at us, rigified and trembling slightly, from every mark of punctuation."[10]

M. B. Parkes's *Pause and Effect: An Introduction to the History of Punctuation in the West* provides, as the book's subtitle suggests, a more comprehensive overview of the evolving histories of punctuation marks, at least in the context of European languages and with the development of the printing press, which significantly stabilized punctuation and largely made it necessary. As Bruno Latour puts it, the printing press brought into circulation "immutable mobiles," standardizing the form of inscriptions yet also enabling them to travel.[11] Parkes explains, "Punctuation became an essential component of written language. Its primary function is to resolve structural uncertainties in a text, and to signal nuances of semantic significance which might otherwise not be conveyed at all, or would at best be much more difficult for a reader to figure out."[12]

It is important to understand, then, that punctuation's history coincides closely with the history of the mechanical reproduction of written language. In antiquity, language was viewed as an oral medium; texts were conveyed by the voice, to the mind. Through the Middle Ages, reading and writing continued to be seen as activities for an elite, educated few, and texts would often be studied and prepared carefully. Readers would practice proper readings, learning when to articulate appropriate breaks. Textual marks were experimented with to indicate such cues, but no standards were in place. With the invention of the printing press, as so many historians have documented, the book became a popular medium. This had two important consequences for the history of punctuation—one technological, the other social. First, now that it had to be set into movable type, punctuation became much more standardized than it ever had been. Second, with the subsequent rise in accessibility of the printed medium, written texts were no longer exclusively for an educated upper class that took time to practice reading aloud, but books were now read alone and by a mass audience. It became important for reading to be made economical and accessible, and for books to contain as little paratextual ambiguity as possible to facilitate reading practices. Punctuation served these purposes.

Punctuation marks are cues that writers leave for readers. They are meant to guide us and suggest how to move through the words that they fall between, giving us pause at appropriate moments to maximize our comprehension. As Parkes puts it, they "resolve uncertainties." Punctuation marks in this sense are reading tools, aids that help convey meaning. They help us hear how text might sound if it were to be spoken. In this sense punctuation marks are sometimes perceived to have musical qualities. Adorno writes, for example, "There is no element in which language resembles music more than in the punctuation marks. The comma and the period correspond to the half-cadence and the authentic cadence. Exclamation points are like silent cymbal clashes, question marks like musical upbeats, colons dominant seventh chords; and only a person who can perceive the different weights of strong and weak phrasings in musical form can really feel the distinction between

the comma and the semicolon."[13] Punctuation as Adorno sees it lends the written word a range of sonic qualities. By extension, one might consider the ways in which it adds a contrapuntal dimension to the text in which it occurs, in its relations with the words it punctuates, and in the ways in which punctuation registers expressivity and affects of a different sort than is possible with alphabetic language. Punctuation marks, in other words, represent a coded system composed of a range of symbols that work with and alongside the alphabet, a distinct but related coded system.

Punctuation's affinities with music offer a suggestive hermeneutic framework too for thinking about punctuation's especially frequent references in indie rock of the 2000s—from Sigur Ros's album simply titled () and the band Parenthetical Girls to the band !!! and Vampire Weekend's single "Oxford Comma," to name just a few examples where the use of marks signifies a countercultural aesthetic departing from the mainstream. In the case of !!! or Sigur Ros's album, for example, how is one even supposed to pronounce the band's name or the album's title? Audiences must be in the know to know that the most common way to pronounce !!! is "Chk Chk Chk." By being stand-alone punctuation marks, both !!! and () resist the primary function of punctuation—making the transition from reading to pronunciation easier—and instead render locution more difficult. The third chapter's discussion of parentheses further contextualizes this aesthetic, as these marks in particular channel an alternative spirit and raise provocative questions about sound.

Textual Shift

At the same time that punctuation might seem to be seeping into our earphones and onto the screens of our handheld devices, I write this book surrounded by a nagging anxiety that the days of the book—and closely connected with this, the idea of what it means to care about punctuation—might be numbered. This sentiment is echoed for example in a wide range of humorous image macros that have circulated online, which illustrate the drastic semantic differences slightly varied uses of punctuation can make—from the widely circulated JFK-Stalin-stripper Oxford comma pun to the

Figure 2. Punctuation image macros. "With the Oxford comma: we invited the strippers, JFK, and Stalin. Without the Oxford comma: we invited the strippers, JFK and Stalin."

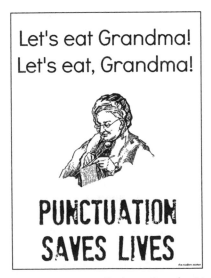

Figure 3. Punctuation image macros. "Let's eat Grandma! Let's eat, Grandma! Punctuation saves lives."

"Let's eat, Grandma" meme. Lurking behind these humorous images, one senses, is a more paranoid critique that we no longer know how to use language correctly, or care to.

Long-form reading is on the decline and many scholars and authors surely wonder who will read the books they devote years of thought and labor to write. Do contemporary academic books speak to only a handful of specialized scholars, or worse yet to the last generation of people who might actually read a monograph with a theoretical orientation? Writing about punctuation and visual culture has in this sense necessarily been accompanied by a certain degree of self-reflexivity, allowing me to think about and speak to broader anxieties about language, and more specifically the changes in textual practices that have coincided with the emergence of digital media. These are among the textual changes I have in mind throughout this book when I refer to the idea of *shift*. Though much of this book comes from a self-reflexive space, the reader will find I have largely left myself out of it—other than in its idiosyncratic writing style and series of curiosities—for the sake of focusing on cultural analysis and putting forward ideas that will hopefully circulate and resonate beyond their own immediate moment of articulation.

This book has two overarching purposes, which at times work on separate but parallel tracks, at other times push up against each other to reveal their limits, and in their most provocative moments work on multiple levels to create a textured inquiry, as if in a performative dance. First, this book aims to simply describe a condition of contemporary culture in a comparative way that draws on a range of objects, texts, and media histories. The condition described is one in which textuality's role has, in the context of the emergence of digital media, undergone profound changes. Most radically, this shift can be understood as one where our commonsense, established understanding of meaning has effectively been disconnected from textual inscriptions. On this level the book builds on and synthesizes many familiar arguments from critical theories about postmodern culture, whose reach has not been fully thought through and mapped out in relation to digital media and culture. I choose to map this shift, for reasons suggested above and

elaborated further below, via punctuation marks and related typographical characters. This goal of the book might be understood as being more expository and observational, a mode that seems to me necessary but not alone sufficient for the critical apprehension of any contemporary or historical cultural logic.

The second aim of this book is less expository and more hermeneutical and imaginative. Broadly, I hope to suggest that the scales and scopes of humanistic inquiry need to be rethought and creatively imagined beyond the confines to which the questions we pose and the objects we examine are often limited. Beginning with single punctuation marks as units for thinking across media forms, I aim to discover unexpected connections and insights that fall outside the parameters of the book's argument and first aim. What opportunities does beginning with a punctuation mark—nearly as microscopic a unit of textuality as one can cognitively process, aside from perhaps a drop of ink or a pixel—open up for a critic essaying to describe a text or for an everyday web user aiming to understand the visual culture of the Internet?

Here, like Walter Benjamin's famous description of the Angel of History, the book moves forward while looking backward, arguing for the continued usefulness of semiotic inquiry in and for the digital age. Now as much as ever, we must attend to questions of the meanings of textual procedures. Just because texts spread so fast, across multiple formats, just because they are here today and gone tomorrow, seeming impossible to apprehend, are not satisfactory excuses to refrain from singling out moments within the visual culture of textuality and analyzing what we see when we engage in such critical isolations. As Jodi Dean writes, "A problem specific to critical media theory is the turbulence of networked communications: that is, the rapidity of information, adoption, adaptation, and obsolescence."[14] Think back to the example of the equal sign phenomenon with which this chapter opened. Facebook—a corporate platform that translates identities into data and then sells it to marketers, particularly via the popular habit of "liking"—encourages an ephemeral engagement with images and the ideas they generate, but in effect its "newsfeed" design emphasizes the nowness and newness of the present and actively discourages

sustained, critical engagement. The very appearance of the equality sign image across Facebook therefore poses a paradox in terms of how to confront its effects, which would seem momentarily vast rather than longitudinally significant. Wendy Hui Kyong Chun would view its paradoxical effects as being part of digital media's temporality that she refers to as the "enduring ephemeral," never quite there but never quite gone, always there for us to access as a moment in history but almost immediately lost and forgotten in a digital archive.[15]

In focusing on punctuation's relationship to visual culture and critical theory, it is instructive to recall one of critical theory's most influential concepts, Roland Barthes's *punctum,* which Michael Fried notes parenthetically in an essay "has proven almost as popular as Benjamin's *aura*."[16] (Key observations in and about theory are often inconspicuously tucked away inside parentheses, as the third chapter will claim.) Barthes introduces the idea in his book on photography, *Camera Lucida.* He expresses dissatisfaction as a critic with language's ability to describe the photographic experience, ontologically based as it is not in verbal language but in the image. He explains that in wanting to write about photography, he became aware of a "discomfort" he "had always suffered from: the uneasiness of being a subject torn between two languages, one expressive, the other critical. . . . For each time, having resorted to any such language to whatever degree, each time I felt it hardening and thereby tending to reduction and reprimand, I would gently leave it and seek elsewhere."[17] He introduces two concepts—the *studium* and the *punctum*—to both address and move beyond this critical impasse. For Barthes, the *studium* characterizes a sort of general interest, a standard reading based in an educated, shared perspective, but as he says, "without special acuity."[18] By way of contrast to this, he develops a discussion of the *punctum,* his introduction of which, even if familiar, is worth quoting fully:

> The second element will break (or punctuate) the *studium.*
> This time it is not I who seek it out (as I invest the field of
> the *studium* with my sovereign consciousness), it is this ele-
> ment which rises from the scene, shoots out of it like an arrow,
> and pierces me. A Latin word exists to designate this wound,

this prick, this mark made by a pointed instrument: the word
suits me all the better in that it also refers to the notion of
punctuation, and because the photographs I am speaking of
are in effect punctuated, sometimes even speckled with these
sensitive points; precisely, these marks, these wounds are so
many *points*. This second element which will disturb the
studium I shall therefore call *punctum;* for *punctum* is also: sting,
speck, cut, little hold—and also a cast of the dice. A photo-
graph's *punctum* is that accident which pricks me (but also
bruises me, is poignant to me).[19]

The idea of the *punctum* allows Barthes to conceptualize a personal
encounter with a work of art, to identify a particular detail in a
photograph that speaks to him as a spectator. It is not something
intended by the artist; rather it represents a unique experience on
the part of the observer that idiosyncratically elevates his aesthetic
investment in a piece beyond the more ordinary level of the *studium*.
Fried explains its central import succinctly: "The *punctum,* we might
say, is *seen* by Barthes, but not because it has been *shown* to him by
the photographer, for whom it does not exist."[20]

As Fried observes, Barthes's *punctum* is one of the most frequently
referenced concepts in theoretical discussions of photography and
related arts. Rather than rehearsing these theoretical appropriations
and debates about photography here, I would prefer to briefly lin-
ger on the term's actual etymology. What is interesting is precisely
that the *punctum* is such an influential, resonant concept in tandem
with the fact that it, as Barthes writes, "refers to the notion of punc-
tuation." Indeed, for all the term's critical circulation, relatively little
has been written about the concept's relation to punctuation, which
is to say nothing of Barthes's own elegant and precise punctuation.
Barthes turns to the concept because the *punctum* breaks, interrupts,
"pricks," "wounds," "rises from the scene, shoots out of it like an
arrow, and pierces" him. The *punctum* as he frames it can both refer
to literal "marks" in an image ("sometimes," he writes, photographs
are "even speckled with these sensitive points") and more metaphori-
cal marks, which are "in effect" punctuated, "rising from the scene."

It is fascinating, if somewhat unintuitive, that Barthes attributes
such punctuations of the image to elements that the artist did not

intend to be there, to characteristics that in his encounter with the photograph he discovers unexpectedly; to what has been seen, not shown, to recall Fried's summarization. It is worth considering what this implies about how Barthes conceptualizes punctuation. Recall that a punctuation mark's purpose in writing is to aid the reader. It is, one could say, a quite intentional mark left in the text for the reader, a figure whom we could analogize to Barthes's photographic viewer. This likeness by Barthes's logic takes us only so far, then, as punctuation marks—unlike the *punctum*—are generally deliberately, even artfully, inscribed by writers. Combined with this move punctuation forges from the writer to the reader, punctuation for Barthes nonetheless seem to be as close as one can get to an appropriate metaphor for parts of a work that are easily overlooked and neglected, not noticed by everyone. In fact, reading the *punctum* more directly in the context of punctuation could serve to revise the concept's tight connection to that which is not artistically intended, to instead associate it with that which is not noticed by most viewers, refined as their observational skills might be.

To align the inquiry to the present questions at hand, I wish to emphasize that a punctuational concept serves as Barthes's answer for moving beyond the impasse or incompatibility between image and language, or what he refers to as the "reduction and reprimand" that take place when "critical" language encounters "expressive" language.[21] It enhances our attention to the production of visual critique to remember that the *punctum* is so intimately tied to punctuation. Punctuation marks hover between and beyond language and image—almost, one could say, both and neither at the same time. Thus it makes sense that they are closely related to Barthes's identification of a way to mediate the impasse between the photograph and the critical text. Focusing on punctuation enables one to move between visual culture and critical theory in a comparative manner, to think through the dimensions of text's visibility in and structuring of both language-based criticism and image-based media.

An additional layer of resonance to punctuation's place in mediating between medium and thought emerges when comparing the aesthetic value Barthes attributes to the *punctum* with Vilém

Flusser's claims about medium differentiality and writing in his 1987 book, *Does Writing Have a Future?* Flusser writes that an "inner dialectic of writing and its associated consciousness, this thinking that is driven by a pressing impulse, on one hand, and forced into contemplative pauses, on the other, is what we call 'critical thinking.' We are repeatedly forced to come up from the flow of notation to get a critical overview. Notation is a critical gesture, leading to constant interruptions. Such crises demand criteria. What is true of notation is true of all history."[22] If for Barthes the dialectic in question is that of image and language and in the space of the synthesis we find critical work, then Flusser offers a similarly dialectical view of criticism, emerging out of opposing processes of "pressing impulses" and "contemplative pauses."

Recall that the title of Parkes's book on punctuation is *Pause and Effect,* where pause is the effect in writing that punctuation historically instantiates. The earliest marks, such as empty single spaces, periods, and commas, aid readers because they indicate where to pause, reducing ambiguity and heightening clarity. On a sentence-level scale, then, following Flusser, one could view punctuation as the inscriptions of such moments of contemplation, pauses allowing readers to stop and think, however momentarily. This book wagers that punctuation across media forms and contexts provides brief moments for thought, collected in the following pages of reflections.

The affinities tying Flusser to Barthes and to punctuation are stronger still. Consider Flusser's following observation, just a few pages after the one cited earlier.

> A scientific text differs from a Bach fugue and a Mondrian image primarily in that it raises the expectation of meaning something "out there," for example, atomic particles. It seeks to be "true," adequate to what is out there. And here aesthetic perception is faced with a potentially perplexing question: what in the text is actually adequate to what is out there? Letters or numbers? The auditory or the visual? Is it the literal thinking that describes things or the pictorial that counts things? Are there things that want to be described and others

that want to be counted? And are there things that can be
neither described or counted—and for which science is
therefore inadequate? Or are letters and numbers something
like nets that we throw out to fish for things, leaving all inde-
scribable and uncountable things to disappear? Or ever, do
the letter and number nets themselves actually form describ-
able and countable things out of a formless mass? This last
question suggests that science is not fundamentally so differ-
ent from art. Letters and numbers function as chisels do in
sculpture, and external reality is like the block of marble
from which science carves an image of the world [23]

Letters and numbers, in the broader view Flusser lays out, correspond
with distinct ways of thinking—auditory and visual, respectively—a
perspective one finds implied here. In the increasingly digital age
of the computer, the visual, numbered mode, Flusser claims, takes
center stage over the auditory, lettered mode that previously pre-
vailed. This formulation coincides with this book's own broader
view of the notion of shift. But for the moment note that, drawing
on richly evocative maritime and sculptural metaphors, Flusser is
trying to understand how categories (letters and numbers) for phe-
nomena might limit our abilities to grasp the full spectrum of expe-
rience, not unlike Barthes's unsatisfactory encounter with the
studium. (We are also not conceptually far removed from Wittgen-
steinian philosophies of language.) Before this passage, he writes,
"The alphanumeric code we have adopted for linear notation over
the centuries is a mixture of various kinds of signs: letters (signs for
sounds), numbers (signs for quantities), and an inexact number of
signs for rules of the writing game (e.g., stops, brackets, and quo-
tation marks). Each of these types of signs demands that the writer
think in the way that uniquely corresponds to it "[24]

While Flusser here makes a passing reference to punctuation
alongside letters and numbers as a distinct set of signs correspond-
ing to a distinct type of thought, it is curious that in his discussion
just a couple pages later, this "inexact" third character set is aban-
doned. If as Flusser writes in these pages, letters describe and num-
bers count, and if he suggests that procedures of description and

counting might exclude alternative epistemological and phenom-
enological dimensions, an example of such a dimension would, one
might strongly suspect, be found in punctuation.

For Flusser and Barthes alike, then, punctuation engenders a
needed but insufficiently pursued frame within which to stage the
critical encounter with media: For Barthes, it offers a passing but
structuring metaphor for a critic's ability to perceive the uninten-
tional mark in the text that makes the work of art exciting and vali-
dates criticism. For Flusser, punctuation is a more literal type of
textuality that corresponds to a logic that is neither for description
nor for counting, neither visual nor auditory. Indeed, what "unique"
ways of thinking could we say punctuation corresponds to? If we
configure punctuation as Flusser's fishing net, what undescribable
and uncountable things will emerge from the ocean?

Importantly, both Barthes and Flusser point to punctuation as
a neglected dimension, if differently. For Barthes punctuation stands
in for the neglected, while for Flusser punctuation is, given his
extensive focus on writing's symbols, more symptomatically
neglected. Punctuation marks as reading lenses for thought raise
interesting questions about what we take for granted. They are tiny
bits of textuality that are smaller units than words—and only the
most sensitive of writers pay careful attention to word choice,
which is to say nothing of punctuation. The speediness with which
we are able to communicate with one another today via the key-
boards of interconnected computers and mobile devices would seem
to trump a certain care for language ensured or taken for granted
by the rhythms and practices associated with slower, predigital
methods of writing. Indeed, a cursory glance at communication
online and in SMS text messaging might even suggest we tend to
forget punctuation altogether—dropping periods and question
marks from the ends of sentences, not bothering to include com-
mas where they once would have been needed.

On the other hand, paradoxically, it might seem that punctuation
is everywhere. In graphic design, in the emoticons we text to one
another, in computer code, in the proliferating textualities we see on
screens in the street and on screens at home. As Johanna Drucker
notes of our "postalphabetic" era, "Contemporary life is more satu-
rated with signs, letters, language in visual form than that of any

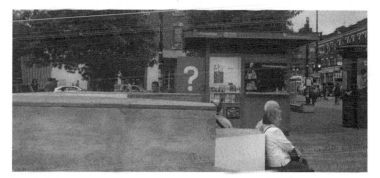

Figure 4. Question mark as vanishing point: information booth outside the Mont-Royal subway station in Montreal. Photo by author, 2013

other epoch—T-shirts, billboards, electronic marquees, neon signs, mass-produced print media—all are part of the visible landscape of daily life, especially in urban Western culture."[25] In this context, one might think of endless examples of punctuation's visibility.

Both lines of thought—that punctuation is nowhere and that it is everywhere—could, it would seem, be argued persuasively. But discerning a distinction helps make this paradox less paradoxical: the first scenario (punctuation is nowhere) relies on a predominantly linguistic conceptualization of punctuation, while the second (punctuation is everywhere) relies on a predominantly visual one, which W. J. T. Mitchell would associate with the "pictorial turn."[26] I therefore take this paradox as a starting point from which to launch the following argument: Language and image, two signifying spheres that we traditionally conceptualize as discrete, today increasingly overlap and change functions as screen technologies proliferate and form the interfaces of everyday life. Punctuation marks, symbols that hover between and beyond image and language, provide a unique opportunity to harness these shifts in language-image relations.

Thinking Punctuationally: *Comma Boat*

While this book relies on the distinction between language and image as being key to making sense of a textual shift that has coincided with the emergence of digital media, I also complicate it. Beyond the provocative ways in which punctuation indexes such

a textual shift, I also want to invite my readers to think about the wide range of ways in which we (can) think *punctuationally*. Here, the following chapters share a significant amount in common with two other book-length works of cultural studies on punctuation. Marjorie Garber's 2000 book of cultural criticism, *Quotation Marks,* brilliantly mobilizes these titular punctuation marks and thinks across literature, media, history, politics, the law, and affect, interrogating how, ultimately, quotation marks paradoxically but necessarily render and take away credibility. As such, Garber demonstrates how punctuation gives rise to ideas and intervenes in broader considerations of cultural discourse. This is a key previous study, and indeed might be the first to demonstrate just how pervasive and generative thinking punctuationally can be. Jennifer Devere-Brody, in her 2008 work *Punctuation: Art, Politics, and Play,* presents a second book to explore such associations, analyzing a wide range of performances and cultural texts not only where we find explicit uses of punctuation but also where we find visual patterns, ideas, or political discourses that recall punctuation marks, from Yayoi Kasuma's politically charged use of polka dots on bodies in her 1960s "naked demonstrations" to driving at night and seeing "bright white lights speeding toward us along an otherwise pitch-black freeway."[27] Following Garber and Devere-Brody, I am compelled to open up any narrow conceptualizations we might have of where we find punctuation. Making this move involves understanding that marks are fundamentally structures of relation, showing us how to bring two different units (usually clauses of language but also image and thought) together. In turn, marks can be—and indeed often already are—mobilized as reading lenses through which to pose questions about how, among various cultural configurations, certain structures and sets of relations might be viewed as behaving punctuationally (such as, very generally, Barthes's *punctum*), which can in turn lead us to discover patterns in political and aesthetic practices. In short, punctuation can help us *theorize*.

The present book's investment in media theory, however, leads it to depart on a trajectory that sets it on a path largely different from Garber's and Devere-Brody's, insofar as it more centrally

posits an argument that punctuation's relationships to digital media allow us to index a large textual shift that has been occurring over the course of the past few decades, a claim that has not been pursued by either Garber or Devere-Brody. This specifically digital shift occurs in a time propelled by technological speed, the global information economy, smart phones, social networking, and corresponding reconfigurations of labor, leisure, and love. Within these new circulations, textuality—letters, numbers, punctuation marks, words, slogans, messages, user manuals, contracts, information, stories, billboards, web pages, and the visual and/or sonic inscriptions of these things—has spread far beyond the books to which it was generally more neatly confined and in relation to which it has tended to be conceptualized. In the process, textual inscriptions themselves have come to take on a greater number of functions used to enable and ensure the efficiency of communication, opening up a whole parallel set of effects, much like the secondary set of inscriptions that shift keys on our computers make possible. In this same cultural condition, everyday language practices carried over from predigital times are also undergoing notable transitions. Content of individual statements becomes briefer, requiring busy, always-connected subjects to surrender less precious time from the seemingly incessant demands of daily life and what Jonathan Crary calls the "unrelenting rhythm of technological consumption" that keeps us awake more hours and controlled by the apparatuses of 24/7 capitalism.[28] Textual shorthand—ubiquitous acronyms like LOL and OMG, combined with the stylishness of leaving vowels out of words—is, meanwhile, increasingly familiar and acceptable in a variety of discursive habitats. While such changes are met with nervous critiques that echo concerns about postmodernity's depthlessness, they are also accompanied by other important features, from an affinity with play to collaborative writing with artificial intelligence that draws on autocorrecting tools built into text-based applications for fixing typos in the final versions of files and messages we send or submit. Such habits of assistance of course might also be viewed with ironic distance, given all the "fails" such "corrects" generate—something

humorous popular blogs and websites like Damn You Autocorrect capitalize upon for comedy.

These everyday changes often seem most effectively registered when removed from mundane, habitual contexts and channeled through artistic work, forcing us to encounter their experiential textures and structures of feeling through distanced creative or hermeneutic reflection. This is the effect spectators experience for example with work by contemporary video artist Ryan Trecartin, often hailed as one of the most original and important contemporary video artists working today. His videos rely on scripts with a prosody that uncannily channels the rhythm and flow of the digital-native generation's communication practices. Made in the middle of night, they almost seem to channel the sleeplessness that Crary observes structuring global, digital exchange. The artist explains, "There's no light coming in the windows at night, and people have fewer distractions—they're not checking their cell phones, and their associations are weirder at night."[29] Probably the most important component of Trecartin's videos are his scripts, which produce uncanny effects through their language's surreal relation to sense; a spectator would have a difficult time following the exact meanings of what the characters in his videos are actually referencing. As Bryan Droitcour notes, "the forms of all the aspects of Trecartin's work—the camerawork, the editing, the music, the makeup, and the costumes . . .—are prefigured in the way he works with words."[30] Trecartin constructs one-of-a-kind, language-laden environments in which frenetic, irreverent characters are simultaneously of our world and not, removed and present, seeming to channel an unconscious logic that is neither and both digital and human. The experience of submitting oneself to them spectatorially is likened by Allegra Krasznekewicz to "riding a roller coaster into the vertiginous depths of the Web or looking through a kaleidoscope on acid."[31] In *Comma Boat* (2013), a movie whose title foregrounds punctuation, the characters' language resembles the claustrophobically narcissistic oversharing of the validation-seeking self constructed by social media platforms crossed with theatricized, bot-generated qualities of familiar spam e-mails more than it does literary conversation or performative computer code.

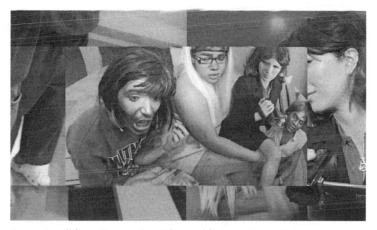

Figure 5. Still from *Comma Boat* (directed by Ryan Trecartin, 2013)

Consider the following dialogue from an early scene in *Comma Boat*, which has four participants, whom in the absence of names I identify with numbers, representing their on-screen positions from left (1) to right (4):

1: And she's not talking about sex or making families that matter. Because she's talking about um particles. Basically. I love particles. What the whore and balls . . . What the whore and balls is she saying? Yes. I love a good comma. That is the name of my cat. Comma.

3: Like survival . . .

1: comma

(4 gestures comma with hand)

3: Like survival

1: Comma. Meow

3. Before gear

1: Meow. Comma

(4 gestures comma)

3. Of the present

1: Comma

3: Type. Mega foundational shiftsssss

1: Shit

3: Shift

X (unknown, offscreen voice): comma.

1: You think you're so smart, you can't say the word shit. You have to say shift. Knots. Try to untie that one. Try to fucking untie that one. Right?

(4 claps)

3: She thinks she can act with her face.

4: Off. Off.

2: Veronica Mars, you're off.

3: Esoteric.

2: Comma.

The third character seems to be more of an official, academic reporter from the media, wearing a suit and holding a handheld camera, in a *mise en scène* that evokes an interview. Like the rest of the entire thirty-three-minute video, originally displayed on three screens, in its single-screen version the scene is not only sonically but visually disorienting, framed by a rectangular frame on the edges that is split in half and features two other camera angles recording the same scene. This is clearly not exactly an interview, because the question/answer format that normally structures an interview is not present. Rather, the characters, especially the first and third, are talking over each other (thus becoming more of a critique of the very genre of the interview), with the first androgynous character, played by Trecartin in a black wig and with his face painted with a purple beard, seeming to negatively react to his or her distaste of the third character's pretentious, academic language ("What the whore and balls is she saying?" "Try to untie that one.").

The best way to read this scene is perhaps as a battle staged between an artist who resists interpretation and a critic who attempts to generate vocabulary to analyze the artist, character 3 versus character 1, high versus low culture, "shift" versus "shit." (It is not lost on me that this dialogue makes the present book's title and critical position vulnerable to the same pun and critique.) In fact, this scene might even be read as a playfully veiled response to Droitcour's *Rhizome* essay about Trecartin, specifically his discussion of the artist's *K-CoreaINC.K (section a)* (2009)—where characters, all named

different national "Koreas" (Mexico Korea, Canada Korea, Hungary Korea) and presided over by Global Korea, a CEO, attempt to meet. Upon reading the video's script, Droitcour notes,

> Punctuation was invented to represent the pauses and pitches of speech; long after it moved beyond this purpose to become a set of standards for clarifying the meaning of written language, punctuation marks were remixed as emoticons when writing began to take on the phatic functions of speech. Trecartin's unruly use of punctuation draws on all stages of its history. When, in the script's first lines, Mexico Korea says "Yaw,,,,,,", the comma does more than make a pause. It's a winking eye torn from a smiling face, repeated until it's a nervous tic. Colons join, parentheses cut, and in the designation of Global Korea's role—before the dialogue even starts—those marks are staggered to herald *K-CoreaINC.K (Section A)* as a drama of belonging and difference, of where the self stands with regards to others.[32]

The eponymous conversation about commas in Trecartin's video made two years after Droitcour's article was published, whether intended so or not, could be productively viewed as a tongue-in-cheek, or even dismissive, response to Droitcour's scholarly analysis of the artist's earlier use of commas. Trecartin, who distances himself from associating with overly intellectual rhetoric and shamelessly admits to preferring MTV over literature, in effect reclaims the comma from critical language and brings it back into his art. He makes "comma" the name of the cat of the resistant character played by himself, reminiscent of that most banal but pervasive culture of Internet comedy: the endless hours of cat videos archived on YouTube.

The comma, the punctuation mark we use to create lists, to elongate sentences, in the dialogue of the scene adds to Trecartin's sonic cacophony, becoming a way to articulate and tie together an aggregation of language as it traditionally does in written language. But the comma, here interjected into another speaker's words, also cuts the critic off, as if to expose her discourse as nonsense. In pronouncing the punctuation mark out loud, the dialogue might also remind us of the act of machinic transcription specific to digital

contexts: as though the characters are dictating lines to be transcribed by an artificially intelligent system, recorded for posterity's sake. Probably even more than that, saying the name of the mark out loud after single words recalls the fashion of speech whereby people repeatedly pronounce the word *hashtag* in conversations—a phenomenon explored further in this book's final chapter. *Comma Boat*'s dialogue in a sense has an air of the narcissistic affect Piper Marshall has written about in relation to the widespread use of the hashtag, where "our current climate is dominated by pithy punch lines that summarize the solipsist's always already uploaded narrative."[33] Trecartin's repeated comma effectively becomes the very mark of the ability to be redefined and recontextualized, to turn against language. Whether it is a "winking eye torn from a smiling face," a command against interpretation, or Trecartin's misshapen hashmark, the comma represents a structuring logic of popular culture in Trecartin's poetic video art.

Notes on the Book's Organization

In each of this book's primary chapters, I aim not only to narrate comparative media histories of a distinct punctuation mark—the period, the parenthesis, and the hashmark—but also to develop discussions and launch rethinkings of theoretical concepts to which the typographical marks in question give rise. I mobilize these concepts to stage nested readings in which the ideas they generate shed light on specific texts and cultural practices and at the same time cross-pollinate one another. I aim to explain how various marks reanimate nexuses of conversations in critical theory to in fact offer fresh perspectives on the cultural histories and aesthetic practices associated with "new media" and the "digital," and especially how they also offer us ways to problematize these categories.

I am therefore not only suggesting that punctuation marks will help anchor an understanding of cultural aesthetics and our specific textual condition, but in effect also allowing punctuation marks to carve out space in which we can reflect on how we write (and do not write) about and across media. In this sense, I build on Lisa Samuels and Jerome McGann's notion of "deformative criticism"

as a mode of "engaging imaginative work." They write that this "alternative moves to break beyond conceptual analysis into the kinds of knowledge involved in performative operation[s]."[34] All acts of interpretation necessarily change a work and "dig 'behind' the text," as Susan Sontag famously declared in "Against Interpretation," and as Trecartin works through in a more roundabout way in *Comma Boat*.[35] Samuels and McGann foreground this very inevitability of critical work, suggesting we apply strategies of literally rewriting and taking apart a text's composition, or isolating parts of it so as to forge connections and discover what new forms of knowledge such procedures might create.

Punctuation as a topic of study in particular seems to invite us to engage in critical play: what if we switch a period with a colon, replace a pair of parentheses with a pair of dashes, or, as the JFK-Stalin-stripper meme pictured earlier suggests, leave out an Oxford comma? Indeed, to understand how punctuation matters, consider doing without it. What if we remove it from text altogether? How would such a move alter meaning? A glance in nearly any book or guide about punctuation will almost certainly include a rhetorical demonstration that juxtaposes two pieces of text containing the same words but punctuated differently so as to demonstrate the significant (and often humorous) semantic differences punctuation registers when used differently.

Parkes offers the following on the first page of his history of punctuation, for example, explaining that punctuation's "primary function is to resolve structural uncertainties in a text." To illustrate this point, he removes punctuation from a brief passage in Charles Dickens's *Bleak House:*

> out of the question says the coroner you have heard the boy cant exactly say wont do you know we cant take that in a court of justice gentlemen its terrible depravity put the boy aside.

Parkes then suggests, "When punctuation is restored ambiguities are resolved:

> 'Out of the question,' says the Coroner. 'You have heard the boy. "Can't exactly say" won't do, you know. We can't take

that in a Court of Justice, gentlemen. It's terrible depravity. Put the boy aside.' "[36]

Another common example that illustrates the strong semantic effect punctuation has and the dangerous consequences of misusing it is in the juxtaposition of two differently punctuated sentences:

A woman, without her man, is nothing.

A woman: without her, man is nothing.

The title of Lynne Truss's *Eats, Shoots & Leaves: The Zero Tolerance Approach to Punctuation* also refers to one of these instructional devices, a bad joke about a panda that walks into a café and shoots a gun because of a wildlife manual's badly punctuated description of his behavior that inserts a comma after *eats* in the description "Eats shoots and leaves."[37]

Several popular image macros raise such questions effectively, too. The series of macros pictured earlier might themselves be viewed as deformative critique, particularly in responding to the tendency to abandon punctuation discussed at the beginning of the introduction, which as these artifacts suggest, we might more accurately rethink as a tendency to misuse punctuation.

These images humorously play with punctuation, demonstrating the ways in which slight misuses of marks can drastically change intended meaning, continuing a popular cultural investment in punctuation that was evidenced by the big success of Truss's 2003 best seller. Due to the digitally generated and circulating nature of these macros, they inscribe an added dimension of self-reflexivity on the shifting uses of language that coincide with digital contexts. While they tap into fears older generations have about abuses of the English language, at the same time, through their very reliance on a popular form of new media, they seem to acknowledge the possibility that rather than viewing this situation as symptomatic of the deterioration of culture, we might instead consider it a *shift,* a less judgmental view asserted by this book's title.

This book offers multiple, but complementary, views on "shift" as a concept. One approach to viewing this shift is to understand

the writing in this book itself as a performance of a textual shift, as an extended exercise in deformative criticism. In effect, I read culture as a vast media–textual fabric and isolate, or to recall Flusser's metaphor, fish for, a series of punctuation marks from it. What, I ask, might these textual isolations teach us about their broader contexts: culture and everyday life? This line of inquiry certainly has its place; it favors knowledge generated by associative logics, close reading, formal observations and speculations, intuitions and counterintuitions, historical coincidences and contingencies It creates a space that allows us to think about the sets of relations at play with typographical structures in cultures of writing and how we might read similar sets of relations in other nontypographical contexts. But it does not aim to forge a repeatable path, or to launch a definitive argument about contemporary society. While the period is examined in detail in the next chapter, the punctuation mark that guides my thought across the chapters is more the ?, not the . or the !.

The book's chapters can each be read individually and out of order, and readers should be able to enter at multiple points with hopefully little confusion. However, the chapters are also organized in a sequential order, posing a sustained question that itself shifts, closely analyzing punctuational trajectories, allowing us to read a series of textual shifts related to new media and the aesthetics of digital screen cultures.

On one level, one can read the movement of the book's chapters as enacting a sustained, playful reference to the literal shift function of a computer keyboard—a key that, when pressed in conjunction with any alphanumeric or punctuational character's key, achieves an alternative inscription effect, often capitalizing a given letter or transforming a number into a punctuation mark. The shift key is, after the space bar (which itself inscribes the originary mark of punctuation— —empty space), the largest key on the computer keyboard, often appearing in two symmetrical positions. Quite literally, the shift key makes the electronic writing of punctuation possible.

The second chapter begins with the period: the most elemental of marks, which gets its own place on the QWERTY keyboard,

just to the right of the M and the comma keys. Interestingly, as I will soon explain, in the original design for the typewriter's—which was later borrowed for the computer's—QWERTY layout, the period was supposed to occupy an even more central position, where the R currently resides. But it was subsequently moved so that all the letters of TYPEWRITER could be found along the top row. Embedded within our contemporary keyboards is this earlier history of punctuational shift.

Thus we start with a mark whose inscription does not require the use of the computer's shift key but that represents a historical shift in design that positioned punctuation in general on the sides of our technological interfaces. The next chapter follows trails of parentheses, symmetrical pairs of punctuation marks that work together and both of which rely on the shift key for inscription, in and out of new media. The fourth chapter takes Twitter's hashtag as a starting point to think about the history of the # symbol, the sign alternately known as number, pound, hashtag, octothorpe, and even by some (somewhat mistakenly) as the musical sharp sign. This character, dependent upon the shift function as well, is, however and importantly, not conventionally or in a literary sense understood to be a mark of punctuation. Rather, this character, like the equal sign, could be understood as what I refer to as loose punctuation. By reading the #'s media history within the book's larger framework, however, I in effect aim to "shift" our very understanding of what punctuation is and can be to include such "loose" characters. This move is productive because this shift is paralleled throughout the logic of digital culture itself, and thinking on its borders will allow us to refine our understanding of the ontological parameters of punctuation in the present context. It seems clear to me that today the # is a form of punctuation and, moreover, that this is significant.

In order to understand the broader significance of punctuation's own shift and relational logics beyond the written text and into the images of our visual culture, I draw on several examples from cinematic media to help illustrate this more culturally pervasive shift. Methodologically, this offers the advantage of extending questions that might normally be exclusively of interest to literary scholars

and bringing them more centrally into the purview of film and media scholarship. Cinematic media in particular pose further conceptual advantages. As many film theorists have noted, film is in effect a combinatory media form, which is not to subscribe to claims that it is a superior medium, but simply to say that it formally integrates literature's narrativity and temporal unfolding with photography's visuality.[38] Since a critical component of this book's approach to punctuation is that, in the context of the emergence of networked computing especially, punctuation indexes a distinct reconfiguration of image and language, cinematic works offer an opportunity to draw attention to both of these punctuational dimensions at once and to their changing relationships with each other.

It is important to acknowledge that punctuation's digital dimensions are being explored quite provocatively in a range of electronic writing practices, most notably in the domain of codework, practiced by artists and writers like Florian Cramer, John Cayley, Mez, Talan Memmott, and Alan Sondheim, as has been studied by scholars such as Rita Raley, Katherine Hayles, and Cayley himself.[39] In order to demonstrate how in the digital age punctuation's reach extends beyond literary practices, I take as an assumption that it is worth devoting attention here to other media forms, where punctuation has been less studied and foregrounded. Moreover, I hope the book's cinematic throughline will be useful to those invested in literary concerns, offering insights about the literary by virtue of its being articulated in and represented ekphrastically by another media form—one that is arguably more constitutive of the fabric of popular culture and thus might represent more widespread ways of thinking about and culturally imagining textuality.

Thus in each chapter that follows, the book throws the textual shift it explores into perspective via a cinematic lens. The cinematic work examined inscribes the mark in question on a literal level, but on an even deeper level also enriches a consideration of punctuation's particular cultural logic that each chapter parses out. Viewed together, the specific movies *Adaptation.* (directed by Spike Jonze, U.S., 2002), *Me and You and Everyone We Know* (directed by Miranda July, U.S., 2005), and *I Love Alaska* (directed by Sander Plug and Lernert Engelberts, Netherlands, 2009)—form

a parallel picture of a shift toward the digital that mirrors the punctuation marks I read them in relation to (the period, parenthesis, and hashmark, respectively). Coming from three distinct historical points in a decade that saw rapid transformations in the influences and uses of digital technologies within popular culture and media, these films index a shifting digital consciousness that begins with anxieties over the dot-com crash that opened the decade and moves toward anxieties about new ways that digitally mediated technologies reshape human intimacy, privacy, information, consciousness, and creative expression—issues whose stakes and consequences only seem to be increasing in magnitude as we settle into the mid-2010s.

Formally and thematically, each film's own relation to the idea of the digital itself also increases as the book proceeds. *Adaptation.,* the second chapter's cinematic text, upon first consideration might seem to be a postmillennial analog anomaly. The film was shot on 35 mm film and features a main character—a screenwriter named after the film's own screenwriter Charlie Kaufman, played by Nicholas Cage—who types his screenplay on a typewriter. Yet Kaufman is tormented by a fictional twin brother also played by Cage, and thus the digital creeps in as an anxiety: materially, as the actor's ability to act with himself is made possible by digital trick effects in postproduction; and narratively, as I will argue, one can read the film allegorically as representing broader anxieties about the digital in the cultural context of dotcommania ideologies.

If in *Adaptation.* the digital is merely a threat the film tries to keep under control, in *Me and You and Everyone We Know* there is no turning away from it, and Miranda July, like *Adaptation.*'s Kaufman character, maintains a semi-autobiographical presence in the movie. The movie is shot digitally and directly thematizes digital media and art, whimsically yet thoughtfully approaching the kinds of intimacy, connections, and creative possibilities new media lend to contemporary life while also interweaving these digital themes—and in a sense even interrupting them—with a tender, old-fashioned romantic comedy. This narrative strand centers on a love story between two young adults who meet in a mall's shoe shop,

and the couple's greatest mark of technological advance is July's occasional use of a cell phone to reach her shoe clerk love interest on a landline. July's film, I argue in the second chapter, moves parenthetically in and out of old and new.

The book's cinematic infrastructure becomes most fully digital in the third chapter with its consideration of *I Love Alaska,* an online episodic mini-movie about an AOL search leak. Distributed online, about the Internet, and with a "script" made only of search queries, this movie's documentary ethics raise questions about the ways in which we have become posthuman data bodies, defined by our identification numbers and dependent upon search epistemologies for navigating contemporary life. These readings thus provide a cinematic throughline to the book's larger argument, reinforcing and distilling the claims I make about shift, punctuation's cultural logic, and digital media, while at the same time figuring as textual counterpoints to them, posing their own complicated questions about narrative, storytelling, postmodernism, and life in our digital era.

Outro: *Is the Man Who Is Tall Happy?*

To stage some recurring themes that surface in the book's attention to punctuation's role in visual culture via cinema, one final illustrative example provides an opportune transition into the next chapter. Michel Gondry's *Is the Man Who Is Tall Happy?* (France, 2013) is an animated conversation between an unlikely pair: the filmmaker and renowned linguist, philosopher, and activist Noam Chomsky.

Gondry filmed two conversations with Chomsky at MIT in 2010, which he presents embellished with beautiful, hand-drawn animations made with neon-colored Sharpies, illustrating and interpreting the stories and ideas Chomsky discusses on the soundtrack. Framed as an effort to race against time and record meetings with Chomsky while he is still alive and well (he is in his early eighties at the time of filming), Gondry focuses their conversations on the philosopher's personal life and his linguistic and scientific theories, rather than politics, about which Chomsky is known to be equally

if not more publicly vocal. The title of the film refers to a discussion between the two that closes the film, about Chomsky's theory of generative grammar. It involves the phenomenon of children intuitively knowing how to construct a question out of a sentence in a complex, counterintuitive way. So they consider an example: to transform the sentence "The man who is tall is happy" into a question, it is necessary to move the sentence's second "is," not the first, to the front of the formation: "Is the man who is tall happy?" rather than "Is the man who tall is happy?" Children always know this, suggesting that to some extent complex linguistic rules appear to be biologically hardwired in our minds.

Interestingly, in the conversation this example starts with, Gondry provides Chomsky with a slightly different sentence to use: "A man who is tall is in the room." Chomsky, however, innocently changes it to "The man who is tall is happy" in explaining his theory. The slight difference is suggestive of the ways in which Gondry and Chomsky, despite their best intentions and generous engagement with one another, do not always quite follow each other (though usually as Gondry humbly presents it, it is he who struggles to express himself clearly to Chomsky). Their subtle miscommunications, and their effort to work past them to understand each other, become one of the movie's charming themes, a fascinating effect of watching them communicate. This simultaneous connection and disconnection is very effectively captured by Gondry's frame-by-frame animations, which assiduously try to keep up with Chomsky's fast-moving associations and deep knowledge, rendering Chomsky's ideas paradoxically abstract yet concrete.

Among the most recurrent images Gondry draws in the film is a question mark, which has the effect of both referring to the more specific linguistic phenomenon of the syntax of the question posed in the film's title but also undoubtedly becoming a more general representation of the mood of the encounter between Gondry and Chomsky—and of Gondry's own modest positioning of himself in relation to the great mind of the philosopher. Over the course of the film, hundreds of question marks move through Gondry's drawings. They proliferate around the words of the film's title in one of the film's closing sequences, and in another (pictured in

Figure 6b), we see a question mark climbing up repetitions of the word WHY, spelled out on their sides and ascending like stairs. Question marks are often not surrounded by other words and letters at all, figuring as characters operating on their own. For example, in another sequence, Chomsky discusses psychic continuity and then the importance of again being willing to be "puzzled by what seems obvious," as the earliest scientists were, such as not taking for granted why a ball goes down rather than up. He says about the simple question "Why?": "As soon as you're willing to ask that question, you get the beginnings of modern science." In an abstract visual sequence accompanying this, a three-dimensional, neon-blue question mark becomes connected to another block-faced, neon-blue question mark on its side and behind it, until there are over fifteen identical question marks, each connected to the others and extending in different directions on the black screen. Eventually about a dozen almost parallel squiggly orange lines with pink dots on the end repeatedly run from the left of the screen to the right, through this question-mark configuration. To the spectator, Gondry then laments in response to Chomsky's discussion that he did not express himself clearly enough: "Once again I had posed my question the wrong way." Gondry had been curious to know whether humans are hardwired to build societies ("cities, art, cars, and so on") the way bees construct hives, but Chomsky had apparently not realized that is what the filmmaker was trying to ask.

Adam Schartoff notes in an interview with the filmmaker, connecting *Is the Man Who Is Tall Happy?* to Gondry's previous films, "It's as though you've almost created a language problem for yourself, and that you're making movies in another language in a way, and you find this other, third language almost—it's like an alternative reality component to almost every film you've made." Gondry seems intrigued by Schartoff's observation, thinking back to Chomsky and his 2005 film *Block Party* with Dave Chappelle in particular: "in both cases, it's hard for me to understand them, it's hard for them to understand me, so we have to connect on a different level, and that really describes this level."[40]

The animated question-mark configuration here and indeed the visually recurring marks throughout the movie thus seem to

become Gondry's visual metaphor for a variety of mental states: the "third language" that punctuation represents, symbolizing the limitations and resolving the tensions of the men trying to sufficiently understand each other; the mode of communication taking place in the interview format, where Gondry poses questions that Chomsky answers; and the tendency for Chomsky himself to be a question poser, repeatedly emphasizing the epistemological need to ask basic questions. This very baseness—Chomsky's interest in posing simple, obvious questions—seems especially appropriately represented by the simplicity of the single punctuation mark. It is as though in Gondry's visual interpretation the question mark captures the profound simplicity of the linguist's thought, which ultimately becomes metatheoretical at the film's end, when Chomsky turns to question the very form of the question itself.

Figures 6a and 6b. Animated question marks in *Is the Man Who Is Tall Happy?* (directed by Michel Gondry, 2013)

This documentary sets in motion some layered themes outlined so far and that this book shall proceed to address. How do punctuation marks stand in for thought and how might they ultimately be more, or differently, effective than language or image at accessing particular epistemological and phenomenological registers? How might punctuation in particular stage an encounter between cinema and philosophy as a way to visualize such registers? Even though this film was made in 2013, and it was made with a notable absence of digital technologies (though its lack of theatrical distribution makes watching it almost entirely dependent upon personal digital media players), would these images of question marks have had the same representational power in a predigital era, before marks circulated so frequently in isolated conditions? Might the mark stand as a trace of the digital condition in a work that otherwise seems to preclude the logics of the digital entirely, from its form to its themes, especially with Chomsky's emphasis on returning to early scientific moments? Did Gondry intend for the mark to so frequently represent his encounter with the philosopher or did the visual dominance of question marks go relatively unremarked and come naturally as a way to transcribe his experience? Are other viewers of the film struck by their presence? Put in other words: Does the question mark figure as a *punctum* in Gondry's reading of Chomsky's words, or for me as a spectator of Gondry's film? Could it, contrary to Barthes's own formation of the concept's personalized interpellation, serve as a *punctum* for both of us?

1

Connecting the Dots
Periodizing the Digital

The Digital Period

The most elemental of punctuation marks, the period gets its own place on the QWERTY keyboard, just to the right of the M and the comma keys. In the original design for this layout, the period was supposed to be housed where the R currently resides. But it was then moved so that all the letters of TYPEWRITER could be found along the top row. Economist Paul A. David explains,

> In March 1873, Densmore succeeded in placing the manufac-turing rights for the substantially transformed Sholes-Glidden "Type Writer" with E. Remington and Sons, the famous arms makers. Within the next few months, QWERTY's evo-lution was virtually completed by Remington's mechanics. Their many modifications included some fine-tuning of the keyboard design in the course of which "R" wound up in the place previously allotted to the period mark "." Thus were assembled into one row all the letters which a salesman would need to impress customers, by rapidly pecking out the brand name: TYPE WRITER.[1]

Embedded within our contemporary computer keyboards, then, is this earlier history of the period's shift, displaced from its originally central position on the keyboard for the sake of showmanship and selling commodities. Imagine the subliminal ways in which we

Figure 7. Shift key

might have thought of punctuation differently if it had indeed occupied a place among other letters, rather than on their peripheries. Punctuation would have an altogether different relationship to our fingers, our muscle memory, our touch, and our bodies. In calling attention to the relationship between punctuation and textual "shift," I evoke the history of keyboard design and a broader idea of how keyboard design might impact the very ways in which punctuation signifies—in line with the phenomenological inquiry Vilém Flusser instantiated.

More directly, however, this chapter is concerned with examining the intersection of textual shift and the period in relation to digital media. This most unsuspecting of inscriptions, when we stop to think about its varied uses, indexes changed signifying practices that correspond with networked computing's digitally mediated communications. One can, in effect, "connect the dots" to narrate the history of digital media as a series of periods, dots, and points. From its typographical redefinition as an organizational structure for Internet protocol in domain names in the 1980s, through the dot-com boom and collapse in the 1990s and early 2000s, to the period-as-decimal-point that borrows from software versioning to mark different phases of the Web and speculative discourses in the early 2010s about what Web 3.0 is and could be, the dot inscribes

the spirit of digital culture. This chapter unpacks the aesthetics, ideologies, logics, and politics of this punctuational inscription. In more than just a flimsy sense, the lesson that emerges from this tale is that the period periodizes the cultural history of the Internet, differentiating its historical phases.

The very term Web 2.0, Tim O'Reilly has claimed, originated as a rehabilitative response to dominant sentiments about the dot-com era ending. Recalling the conference brainstorming session where the term was born, he explains the participants' impression that "far from having 'crashed,' the web was more important than ever, with exciting new applications and sites popping up with surprising regularity."[2] By evoking the software versioning strategies of numbers with decimal points, Web 2.0, and the corresponding retroactive categorizing of the Internet's prior phase as 1.0, was intended to be a corrective to discourses about the Internet becoming history that followed the dot-com collapse.

One could read the shift from the dot to the point, then, as the new media industry reframing the Internet as software that is, depending upon one's perspective, planned-to-be-obsolete or planned-to-be-improved. The dot's continuity but shift in both phases is worth further reflection too: the use of the mark suggests a way of conceptualizing the Internet that is more syntactic than semantic, more mathematical than humanistic, but also elemental and basic.

Conversely, attention to this punctuation mark also opens up an alternate—surface—side of this history that lies not in computer code and discourses about new media but in the very shifting mechanics of human languages that have accompanied the uses of proliferating digital technologies. For example, today in text messages and online conversations we commonly drop periods that would normally and formally belong at the ends of sentences in print. Language pundit Ben Yagoda discusses this phenomenon in a *New York Times* op-ed. He writes, "My 21-year-old daughter once criticized my habit of ending text-message sentences with a period. For a piece of information delivered without prejudice, she said, you don't need any punctuation at the end ("Movie starts at 6"). An exclamation point is minimally acceptable enthusiasm ("See you there!"). But a period just comes off as sarcastic ("Good job on the

dishes.")."[3] Another critic, Ben Crair, observes that the presence of a period in text messaging tends to be read as indicating anger, writing that "digital communications are turning it into something more aggressive," lending the sentence a gratuitous finality.[4] Indeed, one could say that as the period shifts into the middle of web addresses, it tends to shift out of short-form communication of sentences, where the mark is increasingly viewed as unnecessary to convey information quickly.

While the mark continues to possess a key organizational function, the content it organizes has shifted. It no longer plays a strict role in sentence-level communication but takes on a looser role, and now alongside this older role it adopts an additional set of roles in organizing computer-to-computer communication. In other words, the period's functions loosen in natural languages and develop new roles in machine languages. Both sides of the period's roles in digital culture—in natural and machine languages—suggest that it no longer regularly inscribes and signifies finality, but rather a set of qualities that could be better understood as ongoing, architectural, and less conclusive. Viewed from this perspective, the period reflects a larger shift that displaces the priority of the semantic in favor of the mediated epistemological infrastructures that channel the textual practices and protocols of our postprint, digital era.

N. Katherine Hayles has been one of the critics to take on the greatest interest in these changes and to most articulately argue for the need for cross-disciplinary investigations of them. In *My Mother Was a Computer* she writes,

> Now that the information age is well advanced, we urgently need nuanced analyses of the overlaps and discontinuities of code with the legacy systems of speech and writing, so that we can understand how processes of signification change when speech and writing are coded into binary digits. Although speech and writing issuing from programmed media may still be recognizable as spoken utterances and print documents, they do not emerge unchanged by the encounter with code. Nor is the effect of code limited to individual texts. In a broader sense, our understanding of speech and writing in general is deeply influenced by the

pervasive use of code (my deliberate situating of them as legacy systems above is intended as a provocation to suggest the perceptual shifts underway).[5]

Hayles argues that beyond generating new frameworks for approaching new media textualities, we must also specify how the language of computer code bears continuities with the distinct historical textual regimes of speech and writing that have been elaborately theorized by semioticians and literary historians and the ways machine languages present undeniable, significant ruptures with them. But in her formulation, she also importantly acknowledges that the effects of code upon language extend beyond literal inscriptions of code. The "broader sense" of which she speaks suggests that code is part of, even exemplary of, a larger shift in textual logics and systems that cuts to the core of today's communication practices and that is reconditioning worldviews (not deterministically or unilaterally, but reconditioning nonetheless). Punctuation marks in particular, I argue here, map paths upon which one can examine the nature of these changes, signaled by the term *shift*.

The route this chapter takes to map this shift begins with some considerations of the cultural logic of the period, collecting examples and comparative questions from across a range of sites and discourses in visual culture, politics, digital etiquette guides, and literary criticism. Once this logic is mapped, I turn to two analyses that stage two sides of the typographical period's cultural logics and textual shift across the information age. The first, taking us back to the 1980s, will look at the ways in which the mark was in effect redefined as a "dot" by computer programmers in Internet protocol documents. This analysis, so to speak, takes us "inside" the logic of the period's textual shift into digitality, considering its literal redefinitions, infrastructural transformations, and new role in computing. By contrast, I juxtapose this with an analysis that repositions us to an "outside" of sorts to these logics. Moving forward in time two decades, yet to an older media form, I explore a probably unexpected text, Spike Jonze's 2002 film *Adaptation*. I argue that the interpretation of this film—a film that has generated endless interpretations—is enriched by situating it in a different phase in

digital culture marked by the dot-com frenzy. The title's little-noticed period in fact offers what could be taken to be a synthetically symptomatic reading of the film's significance, making sense of it in its historical context when digital dreams saturated public discourses and the national imagination. The chapter concludes by considering periodization as a type of knowledge work, asking how the typographical period's textual shift maps onto notions of digital periodizations more broadly.

Zeroing In on the Period's Cultural Logic

The period, off to the side on our typing interfaces, with its no-frills simplicity and ubiquity, might not seem worthy of much fuss. It sits firmly but quietly in the middle of a holy trinity of sentence-ending marks. On its one side rests the uncertainty of the question mark and on its other side one could locate the overpowering certainty of the exclamation mark. These two other terminal points tend to elicit stronger aesthetic convictions in our cultural imaginations than their neighbor in the middle—soliciting the disdain of everyone from F. Scott Fitzgerald to the bloggers of Excessive Exclamation!!, a website devoted to visually documenting various cultural artifacts and signs that illustrate a persistent overuse of exclamation marks.[6] David Shipley and Will Schwalbe make sense of this trend in their digital etiquette book, *Send: Why People Email So Badly and How to Do It Better.* They write:

> Exclamation points can instantly infuse electronic communication with human warmth. "Thanks!!!!" is way friendlier than "Thanks." And "Hooray!!!!!" is more celebratory than "Hooray." Because email is without affect, it has a dulling quality that almost necessitates kicking everything up a notch just to bring it where it would normally be. . . . The exclamation point is a lazy but effective way to combat email's essential lack of tone. "I'll see you at the conference" is a simple statement of fact. "I'll see you at the conference!" lets your fellow conferee know that you're excited and pleased about the event.[7]

Given that one of punctuation's conventional uses is to convey a writer's tone to a reader, communication in digital contexts would

Figure 8. Excessive Exclamation!! blog

seem to particularly need punctuation to convey tone. The marks help recipients know how to read messages in media whose users often lament not being able to "read" each other's moods, finding that with no voice to carry them, tones are easily misinterpreted. This offers an explanation not only for the recent pervasiveness of punctuation that explicitly registers affect: "excessive exclamation" but also even more popularly, emoticons.

Iconographically, wireless technologies also use the exclamation point to instill panic. For example, when a computer is unable to connect to a network, and the four bars signaling connection

strength on a monitor display do not fill, an exclamation mark is superimposed over the empty bars. One of the goals of this book is to call our attention to and reflect on such images, whereby textual inscriptions have come to form a patchwork of iconography throughout the visual culture of digital media, engaging in modified practices of signification. As we asked in the previous chapter in relation to the isolated equal sign removed from mathematical statements: Is the use of punctuation in digital culture as iconography, disentangled from its ties to language, something new, and if so what does it signify?

In contrast to the question mark and exclamation point, the period's seeming neutrality projects a certain ambivalence, if it projects anything at all. In her witty *Atlantic Wire* article, "The Imagined Lives of Punctuation Marks," Jen Doll personifies various marks, writing,

> The period is the good-on-paper guy or girl (he/she is unisex really). You'll never really fall in love, but you'll appreciate and respect the Period deeply. And you do, at the end of the day, realize in your heart of hearts that you need him or her. Inevitably, however, you'll cheat on the Period with the Ampersand, Semi-Colon, or possibly the Interrobang. The Period keeps an impeccably clean house and can be relied upon to come and visit you in the hospital. He/she always forgives. Full-stop.[8]

Yet even this seemingly inviolable inscription can elicit controversy, as in Barack Obama's 2012 campaign for a second presidential term. The campaign's slogan was "Forward." A *Wall Street Journal* article reports: "The period was subject of a spirited debate as Mr. Obama's senior advisers and outside consultants spent hours in a conference room at their Chicago campaign headquarters deliberating over the perfect slogan, according to an adviser who was in attendance. Does a period add emphasis? Yes! Does it undermine the sense of the word? Maybe!"[9] (The article also illustrates how nearly impossible it is to *not* play with punctuation when writing about it.) If "forward" was intended to project voters into the future, the period following it, some feared, seemed to halt the

word—and the idea it stands for—in the present. Catherine Pages, a Washington, D.C. art director, was quoted in the newspaper as saying, "There's been some speculation that the period really gives the feeling of something ending rather than beginning." Invoking the punctuation mark's "full stop" alias, one of the president's advisers and former chairman of the Council of Economic Advisers, Austan Goolsbee, explained, "It's like 'forward, now stop.' It could be worse. It could be 'Forward' comma." Linguist George Lakoff chimed in to the conversation, responding to questions regarding whether it was even proper English to include a period after one word, confirming that the single word is indeed a legitimate imperative sentence: "You can look at the period as adding a sense of finality, making a strong statement: Forward. Period. And no more. Whether that's effective is another question."

News outlets and critics of Obama noted the slogan's ties to communist propaganda campaigns by the Soviets that also heavily used the word, but notably, they usually added an exclamation point: "Forward!" The *Washington Times,* for example, ran a story titled "New Obama Slogan Has Long Ties to Marxism, Socialism."[10] Less enthusiastic and more understated than its Soviet counterparts,

Figure 9. Obama's 2012 "Forward." campaign

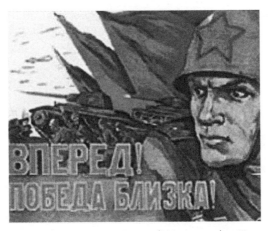

Figure 10. Soviet wartime poster: "Forward! Victory is close!"

Obama's mark is more ambivalent: it might simultaneously read in conjunction with the "Forward" it follows as opening a conversation or, under the media's unrelenting microscope, as cutting off possibilities for imagining what that "forward" might mean.

The period, as these illustrative examples drawn from popular culture and literature suggest, is not as definitive or neutral as we might tend to think. Once we spend some time with it, we realize that rather than making a statement it in fact raises more questions than it answers—about how effective our language is in communicating desired meanings, and about what our desired meanings are in the first place. In every writer's inscription of a period there is a loaded paradox: one is relieved to have completed a sentence, but in this moment of relief one confronts an anxiety that threatens to overwhelm any sense of relief its inscription might have achieved. (Does something come next or have I finished? If something comes next, what is it? Is it someone else's turn to speak? Or must I come up with something else to say?) Every period, in other words, seems to disguise at least four question marks. In this sense the period inscribes many of the same anxieties over finality that the idea of periodization does for many historians and humanists.

Defining the Dot

Alexander Galloway suggests that the social order of our current digital or postmodern period (descriptors he self-consciously alternates in using) is based on a configuration of control that is represented by the Internet's style of management—its protocol—established through the circulation of Requests for Comments documents (RFCs) that set standards for computer-to-computer communication. The logic of control set by these protocols, Galloway explains, is characterized by a contradictory pull whereby on one hand Transmission Control Protocol/Internet Protocol (TCP/IP), which transmits data between computers across networks, "radically distributes control into autonomous locales," while on the other hand, Domain Name System (DNS) protocol, which translates web addresses in natural languages into numerical IP addresses, "focuses control into rigidly defined hierarchies."[11] Thus even though TCP/IP might shape a dominant impression of the Internet as unbound, horizontally sprawling networks whose inorganic logic is impossible to grasp, DNS has the opposite effect, configuring a highly regimented, hierarchical tree structure responsible for facilitating successful communication between computers.

It is here, with the vertical, hierarchical, ordered logic of DNS protocol, where the actual dot of web addresses carries a new procedural function in the computer age. The dots in web addresses break up the command of control into subdomains, where the label following the last dot on the right (such as com, edu, gov, org, or two letter country codes like ca, au, fr, uk) is the top-level domain, and the subdomain hierarchy descends from right to left. As Jon Postel and Joyce Reynolds explain in RFC 920, a policy statement on domain requirements, "in the future most of the top level names will be very general categories like 'government,' 'education,' or 'commercial.'"[12] Indeed, it is also in an RFC such as this where the punctuation mark might be understood to be officially though casually renamed and redefined.

Across the various standards-setting documents for the Internet, the "." character is treated as a noun, not just a mark of punctuation. In fact, it is often punctuated further, surrounded by quotation

marks, foregrounding the intentional textuality of the punctuation, as if to call our attention to a mark so small we might otherwise think it is a typo or overlook it. In this context, if spoken aloud, it becomes a word to pronounce, not just a mark that aids the reader's flow in pronouncing other words. We now write periods in web addresses before we write a website's top-level domain, which, in Paul Mockapetris's more technical language in RFC 1034, "mark the boundary between hierarchy levels" of "name spaces."[13] Nam June Paik's collaborator, net activist, and Name.Space's founder Paul Garrin perhaps best articulates the character's newly achieved significance: "With the stroke of a delete key, whole countries can be blacked out from the rest of the net. With the '.' centralized, this is easily done. With the '.' decentralized such a deletion is not unilaterally possible. Control the '.' and you control access. Control the content of the '.' and you also control the market."[14] In other words, the architecture of the Internet relies on the character in its organization of web pages and in the chain of commands required to take us where we want to go. Every time we visit a website, we need to use the character to get there. This cannot be said of any other character. Nor can it even be said of the composition of every sentence in human languages: there is always the possibility of ending with a question or exclamation mark, or today, in the increasingly short messages we use to communicate with each other, with nothing at all.

This punctuational shift is perhaps most immediately perceptible via changed terminology: no longer a period, it is now referred to as a "dot." In RFCs 1034 and 1035 from 1987, a pair of documents widely credited for defining and setting the standards for domain name protocol, Mockapetris defines the mark as such: "When a user needs to type a domain name, the length of each label is omitted and the labels are separated by dots (".")."[15] Mockapetris's parenthetical quotation of the character (symmetrically triple punctuation at that) in effect serves to name the mark. One could read it, as similar parenthetical expressions often are supposed to be read, as defining unfamiliar terms for future use in a text. In effect it says: "from here on out the "." character will be referred to as 'dot.'" One might almost interpret these RFCs as documents that

are renaming and redefining punctuation insofar as they imagine and set standards for new textual uses of the characters in the hopes of optimizing the Internet's future—for technologies that run it and users that operate it.

In their illustrated history of the Internet, Katie Hefner and Matthew Lyon have noted the importance of the particular tone and the rhetoric of RFCs. They describe Steve Crocker, the author of the first such document, which was about the "basic 'handshake' between two computers," as an "extremely considerate young man, sensitive to others." They suggest that his personality inflected the language of the first RFC, written in a bathroom in the middle of the night so as to not disturb Crocker's housemates. Even the note's title of "request for comments" was named politely to "avoid sounding too declarative." Hefner and Lyon explain, "The language of the RFC was warm and welcoming. The idea was to promote cooperation, not ego. The fact that Crocker kept his ego out of the first RFC set the style and inspired others to follow suit in the hundreds of friendly and cooperative RFCs that followed."[16] Computer scientist Brian Reid notes about this first document's rhetorical friendliness, "It is impossible to underestimate the importance of that. I did not feel excluded by a little core of protocol kings."[17] It is worth considering how punctuational thinking metaphorically textures this history. We might recall that punctuation is the part of written language that lends it tone, and specifically, the period is the mark of punctuation that lends writing a declarative tone (ending a phrase, sentence, or thought). Does it not almost seem inevitable, read from this perspective, that these documents attempting to thoughtfully open up an inclusive and evolving dialogue would redefine with special care the inscriptions that tend to lend certainty and finality to our thought?

And if we think the period is declarative, imagine the extent to which early Internet protocol designers might have wanted to avoid the even greater assertiveness of what Walter Ong refers to as the exclamation point's standard "sense value."[18] Consider for example Crocker's fellow Internet pioneer Jon Postel's 1979 memo IEN 116. (IENs, or Internet Experiment Notes, were a shorter-running series

of protocol documents modeled after RFCs that Postel edited from 1977 to 1982.) It reads:

> It is strongly recommended that the use of host names in programs be consistent for both input and output across all hosts. To promote such consistency of the internet level, the following syntax is specified:
>
> The SYNTAX of names as presented to the user and as entered by the user is:
> ! NET ! REST
> where:
> NET is a network name or number as defined in "Assigned Numbers" [1]
> and
> REST is a host name within that network expressed as a character string or as a number. When a number is used, it is expressed in decimal and is prefixed with a sharp sign (e.g., #1234).
>
> Note that this syntax has minimal impact on the allowable character strings for host names within a network. The only restriction is that a REST string cannot begin with an exclamation point (!).
>
> The !NET! may be omitted when specifying a host in the local network. That is "!" indicates the network portion of a name string.[19]

Without getting bogged down in the details of network infrastructure, one can discern at least two points worth considering for our present purposes. First, Postel explicitly defines here a new role for the exclamation point. And second, this redefinition rests on a fundamental assumption about our expectations about punctuation in natural languages—the term used to refer to languages humans speak and write (which are of course far from "natural"), as opposed to machine languages like code. This assumption is that punctuation is in a sense not as necessary as letters and digits; it is more disposable from language, perceived to have a hierarchically lower value than other types of characters. The exclamation point, in other words, can be redefined precisely because one does not need it to uphold its normal sense value. Domain names can be written

without them. In this way, then, one can begin to understand how punctuation registers more precisely and cleanly than other elements of language the textual shift from human languages to machine languages that correspond with the interconnections forged between digital technologies.

On one hand, in a web address the period continues to mark the end of a semantic unit, insofar as we might understand a name space as a semantic unit. In this sense, and in a very real way, the period continues to organize our experience of textualities and communication. On the other hand, the punctuation mark takes on an irrevocably different role—one that is less for aiding speech in the classical sense of punctuation that has been explicated by scholars like M. B. Parkes and Walter Ong. Ong, for instance, writes in his study of the first punctuation marks (the period, comma, and colon) in Elizabethan and Jacobean English that in predominant early uses of all three marks, "the clarification of the syntax is coincidental. The grammarians are interested primarily in the exigencies of breathing."[20] It was only in later medieval writing, after writing came to be culturally valued more than speech, that the period's function shifted to primarily syntactical clarity. With textuality's increasingly close relationship with computer languages, the period's primary sense value evolves again. Indeed, with the dot one detects a shifting role of punctuation that represents a much broader and more significant textual shift that indexes language's modified role in the digital age. Now, the punctuation mark emerges as an inscription tool to help manage the Internet's growth in the 1980s.

Adaptation.'s Period

If the period steadily began to gain recognition as a dot in the 1980s, I will now propel us twenty years forward, to a moment after the dot became a fixture across not only the infrastructure of the circulation of visual culture but across the surfaces of it as well, with the centrality of the dot-com craze in the United States at the end of the 1990s. To settle into this time frame and typographical character, I wish to consider what at first would seem to be an extremely

unlikely outlier as an example: a hardly noticed yet ingenious mani-
festation of the punctuation mark at the title's end of the film *Adap-
tation.* (directed by Spike Jonze, U.S., 2002). While this period
fairly consistently appears in official references to the film's title and
throughout its marketing, it is more often than not neglected in
casual and even scholarly references to the film, demonstrating just
how unnecessary and unobserved punctuation can be. The film,
though—which takes writing, and even more specifically the anxi-
ety of writing, so seriously—clearly intends and is enriched by its
period. Beyond just encapsulating anxieties about writing and nar-
rative ending, one could read this period as also inscribing a his-
torically specific set of anxieties in the United States about the
(momentary) ends of technological enthusiasm and investment, a
claim I will move toward here.

Nicolas Cage plays two lead characters: a tormented Charlie
Kaufman, an autobiographical version of the film's real-life screen-
writer of the same name (who in the film is fresh from writing
Being John Malkovich, a 1999 film Kaufman did write); and his
carefree twin brother, Donald, also a screenwriter in the film but
with no real-life referent. Charlie, admired for his writing talent
and originality, is enlisted to adapt Susan Orlean's (Meryl Streep)
New Yorker story-turned-book *The Orchid Thief* for the screen.
The film focuses on Charlie's struggle to adapt Orlean's work. He
wants to resist the Hollywood clichés. As he puts it to the studio
executive Valerie Thomas (Tilda Swinton), who has solicited his
adaptation: "I just don't want to ruin it by making it a Hollywood
thing, you know. Like an orchid heist movie, or something. . . .
Or, you know, changing the orchids into poppies and turning it
into a movie about drug-running. . . . Why can't there be a movie
simply about flowers?" He continues, "I don't want to cram in sex
or guns or car chases. You know? Or characters, you know, learn-
ing profound life lessons. Or growing, or coming to like each other,
or overcoming obstacles to succeed in the end."

If the first two-thirds of the film focuses on Charlie's neuroses
and writer's block (often conveyed by a recurring voice-over that
draws us into his obsessions and afflictions), then the final one-third

self-consciously and ironically crams in all that Charlie was trying to keep out. The film unravels, sweeping into its narrative orbit everything its main character wanted to avoid: sex via an unlikely romance between Susan and her orchid-expert muse John Laroche (Chris Cooper); a drug-running scheme that Charlie discovers Laroche is orchestrating in Florida; and a fast-paced car chase to a swamp where Susan and Laroche run Donald and Charlie down, leaving Donald shot dead and Laroche killed by an alligator. And even that most important of Hollywood conventions, a moral: "you are what you love, not what loves you."

Intricately interweaving and blurring fiction with reality, the film thus asks its viewer to reflect on what adaptation means and entails. Is Jonze's film ultimately a true adaptation of Orlean's story? Are its meandering attention to *The Orchid Thief* and insertion of the Kaufman twins and Hollywood clichés unfaithful to its source, or is it a faithful adaptation precisely insofar as it transposes *The Orchid Thief*'s own meandering attention to its subject, Laroche? Is the film about the real-life Kaufman and a fictional twin brother, or do both of Cage's characters represent two competing halves of the same real-life Kaufman torn between maintaining an original, independent vision and selling out to Hollywood? (With screenwriting credits and Oscar nominations for both Charlie and Donald, this was the first time a fictional person was ever nominated for an Academy Award.) Whatever one's ultimate reading is, *Adaptation.* is surely, at least partially, about the anxiety of ending.

Adaptation.'s seemingly tacked-on ending has been scrutinized in much of the film's criticism, leaving spectators uncertain of what to make of it. In his otherwise positive *New Yorker* review, David Denby representatively writes of his disappointment with the ending:

> What then envelops Orlean and Laroche and Charlie (who writes himself into the story) is awful nonsense. Drugs, guns, car crashes, alligators—the movie becomes a complete shambles, and far more desperate than anything conventional filmmakers would fall into. It's hard to know how to read this mess of an ending. . . . The trouble with experimental comedies is that it's often impossible to figure out how to end

them. But at least this one is intricate fun before it blows itself up.[21]

While Denby and a significant number of others seem to find the film's conclusion condescending and alienating, I disagree. It is certainly a joke, and one that we are allowed in on. After the action-packed narrative ending, however, the film in fact does not end. In a smart analysis of *Adaptation.* (which despite its thoughtfulness, representatively neglects the title's punctuation), Joshua Landy considers seven possible interpretations of the movie. He focuses on the significance of the film's true ending:

> Recall, however, that *Adaptation* closes with a time-lapse sequence of daisies on a meridian, an astonishingly powerful sequence, with rhythms borrowed (appropriately enough) from the Fibonacci series and set to music that ends in a lush, ethereal harmony [The Turtles' "Happy Together"]. What if this sequence were not just the finale but also the telos of the movie? What if the entire film were simply building up to the daisies on the meridian, indeed making them possible, turning them for the first time into something that can be noticed?
>
> This, I want to claim, is the deep strategy of the film, the seventh and only successful approach, the one that finally brings about a victory for the nonnarrative (the static, the cyclical) over the narrative.[22]

Landy claims that *Adaptation.*'s motivating question is how to make a cinematic narrative "simply about flowers," recalling Cage's words to Swinton. The film, Landy reasons, delivers an exaggerated, complex, and overstuffed narrative to satiate our desire for narrative beyond any reasonable doubt, so that by the time we see the flowers that close the film, we appreciate them. In the end, the goal—the "deep strategy"—is successful, and the viewer has arrived at a point of being able to notice the flowers and appreciate them for what they are. In a sense, according to this compelling interpretation, the entire rest of the film we have seen until this point, with all its loopholes and fictions, has canceled itself out to finally become a film "simply about flowers."

Yet one could in fact read past the flowers to the film's period as offering its ultimate meaning, an added interpretation of a film that invites nested layers of reading. The period, standing for writing's final mark and an ending that goes unnoticed, inscribes all of the anxieties over finality that the film is about. I have little doubt that the real-life Kaufman, no stranger to including literary devices with multiple layers of meaning in his titles (his directorial debut in 2008 was the acclaimed *Synedoche, New York*), is registering in this single dot the many narrative desires, anxieties, and interpretations the film stages. As a mark that ends a sentence but normally not a film title, the period's placement asks us to think twice about how *Adaptation.* ends. Out of place and tacked on, does the period resemble or counterbalance the film's own spectacular denouement? At the same time could it be just conspicuous enough to catch our attention as the true finishing touch—*the point* of it all—much like the film's closing flowers? Indeed, beyond its closing time lapse of flowers, the key to the film could be understood to lie in its period, since it at once evokes the writing process and an ending out of place.

As much as the period might seem to end the conversation and be *Adaptation.*'s final point, I would not stop there either. We should not forget when this movie was made. This particular punctuation mark was prominent across popular culture in 2002. To read the film in historical context, one might recall that the late 1990s and early 2000s were among other things characterized by great hype over the dot-com boom and crash. Discourses in an increasingly globalizing American society were saturated and undergirded by a hope bordering on greed invested in the futures of new Internet companies, followed by a quick realization that such a creative, economic, and expanding technological utopia could not be sustained—a historical lesson that the contemporary wave of excitement about social media seems not to have learned. As Andrew Ross puts it in his study of Silicon Alley workplaces, "In next to no time, the Internet gold rush story sucked in all the available currents of public attention."[23] Geert Lovink also emphasizes the pervasiveness of dot-com discourses during this time: "For a short while, around 1998–2000, the rhetoric of the New Economy was hot and glamorous; Internet reporting was everywhere, from

the entertainment sections to media pages and IT supplements."[24]
A symptomatic, situated analysis of *Adaptation.* can be enriched by
understanding the movie, particularly the attitudes and actions of
the twins portrayed by Cage, as deeply formed by and responsive
to the cultural ideologies of this particular historical moment's "dot-
commania," to borrow Lovink's phrase for the phase.

As the new millennium approached, news outlets and analysts
also talked with frequency about Y2K as though it would bring
about apocalypse. Our computer systems, and by extension our net-
worked world, were based on programs that temporally stored and
used years' last two digits. The logic underlying the panic had it
that now the first two digits would change and throw things—
including life-sustaining systems—out of whack. January 1 came
and passed, and everything was fine. But in only a few months' time,
with these anxieties hardly settled, there was new reason for panic.
The new technology-based economy (often referred to just as "the
New Economy") unraveled: many Internet start-up companies
turned out to be making less money than they had reported; many
were fined by the government for misleading the public; many
declared bankruptcy; and many of their employees in the industry
were left without jobs. The riskier nature of the work they had
participated in and the career decisions dot-commers had
made—often abandoning high-paying and stable jobs, which Gina
Neff argues in her ethnographic work with New York City's Sili-
con Alley entrepreneurs characterizes a broader shift in U.S. eco-
nomic history at this time—proved to have their consequences.[25]

The dot-com crash that began in March 2000 was soon followed
and accompanied by 2001's September 11 terrorist attacks in New
York City. To reappropriate a remark from Walter Benjamin's poetic
ruminations, these occurrences had a cumulative effect of "piling
wreckage upon wreckage."[26] A large chunk of the country's strong
sense of invincibility and inflated prosperity was revealed to have
been built on false promises and beliefs. People lost jobs and were
forced to redirect career paths, and a nation that imagined itself as
a first-world safe haven from terrorist attacks lost thousands of its
citizens in a symbolic act of violence, leading the nation to embark
on a deeply ambiguous and one-sided "War on Terror." Though

these events did not lead to the radical reevaluations of the national dreams they were bound up with that one might have hoped would result, these events, and the ways in which they were retold in the media, had all the makings of a sensational Hollywood ending.

Adaptation.'s filming took place between March and June 2001, and its theatrical release was in late 2002. The dot-com boom and bust thus historically coincided with the film's development and production: Kaufman had written two drafts by September 1999 (close to the height of the dot-com boom) and completed a third in November 2000 (just months after the crash had begun). I note this context to recall the zeitgeist of the film's period of production, characterized by the dot-com ideologies of speculation, greed, big risks, and big hopes—and the sudden big disappointments—that immediately preceded it. *Adaptation.*'s characters are explicitly working in Hollywood, a media industry that scholars such as Neff in *Venture Labor* point out paralleled the new media industry at the time. In multiple scenes we see characters participating in the kind of social networking, meetings, technical seminars, and conversations about innovation and creativity that were also so constitutive of and influenced by the dot-com bubble.

Though the dot-com context is not obviously legible in Jonze's film, its environment and its ideologies are subtly yet fundamentally intertwined with the film's significance. Moreover, there are markers of the period within the movie that do make this historical moment legible. Beyond its characters' enmeshment in the media industry milieu and the frequent images we see of Donald working on screenplays at his computer (by contrast Charlie—the quality, original writer of the two brothers—of course prefers a typewriter), Internet entrepreneurialism does appear within the film's narrative, even planting the seed for the movie's unraveling. In one blatant departure from *The Orchid Thief*, a few years have passed, and we see Susan drunk and, as a version of the script indicates, "dolled-up" in a hotel room.[27] She calls Laroche. We see him in a room that had not been described in the 1999 scripts but is described in the November 2000 version as a "little boy's bedroom," "now filled with computer equipment. Posters of naked women adorn the walls" (76). After Susan asks Laroche how it's going, he updates her:

> Great! I'm training myself on the Internet. It's fascinating.
> I'm doing pornography. It's amazing how much these suck-
> ers will pay for photographs of chicks. And it doesn't matter
> if they're fat or ugly or what. (76)

Laroche's new self-trained Internet pornography start-up is a star-
tling shift in trajectory from his intense, obsessive involvement
with orchids. It is both symptomatic of the time and an ironic exten-
sion of the film's running reminders of the connections between
orchids and sexuality: as if web porn is the technological version
of its counterpart in the natural world, orchid collecting, where
both hobbies are driven by obsessions, arousals, and specialized
tastes. Laroche's new undertaking, though, is also part and parcel
of the film's deeper theme and narrative ending of selling out, which
we see enacted as the fundamental conflict of interest between
Charlie and Donald. Laroche's new embrace of Internet porn thus
stands for the film's "bad turn," becoming a pivotal example of
exactly those Hollywood clichés of sex and money that Charlie did
not want to sensationalize his script.

What I am suggesting, which I want to neither overemphasize
nor underemphasize, is that put in context the bad narrative Char-
lie tries to avoid in the film is fundamentally bound up with the
(generally unattractive) ideologies of dot-com entrepreneurialism
that were dominant throughout American society at the time the
film was in development and production. In a sense, too, this pre-
cisely furnishes the additional layer to and crucial difference with
The Orchid Thief that Kaufman has contributed in his own adapta-
tion of the source material. The process of adaptation itself—as we
see in a variety of postmodern film adaptations, from Amy Hecker-
ling's spin on *Emma* with *Clueless* (U.S., 1995) to Baz Luhrmann's
updated cinematic treatments of literary classics, *Romeo + Juliet*
(U.S., 1996) and *The Great Gatsby* (Australia/U.S., 2013)—is about
modifying texts in current contexts, inviting spectators and readers
to think about the continued yet modified relevance of older ques-
tions and concerns. The unusual period of *Adaptation.*'s title thus
propels us to consider how the film as an adaptation is punctuated

by the new historical context in which it was created. And in turn, the added narrative layers—the film's self-reflexive anxieties over writing, ending, and selling out—are imbricated in a critique of the dominant social and cultural values that are encapsulated in the dot of the dot-com and open a window into an American psyche witnessing the sharp burst of the bubble of its presumed technological and economic prosperity. Read against this backdrop, the film's deliberate period also provides an opportunity to consider the film's persistent resistance to closure. A punctuation mark that normally closes might here be taken as resisting the dominant "com" of the time that it accompanied (which, one might remember too, stands for "commerce")—reminding us that this film is ultimately a challenging, self-reflexive experiment in narrative storytelling, not commercial fare.

We thus note how the film's punctuation mark ties back to our consideration of the period's textual shift in digital contexts. If, as we observed, the period today is arguably no longer primarily used to end sentences, then *Adaptation.*'s period performs this change, understatedly mediating the shifting and loosening of its epistemological certainty and the range of new roles it now has in the digital "period."

Figure 11. Nicolas Cage staring at his typewriter, as tormented writer Charlie Kaufman in Spike Jonze's *Adaptation*. (2002)

Periodizing the Period

In her book on quotation marks, Marjorie Garber notes that the pun, a linguistic *shifter* that in different utterances signals different referents, can be a way of "getting at the radical capacities to *mean* their various and often contradictory meanings." She claims, "the mode of argument that takes words seriously—and takes them most seriously when confronted with their capacity to and for play—is an aspect of rhetorical criticism that has historically frightened some rationalist readers, by confronting them with their poets'—or their own—unexpected inner thoughts."[28] With the power of word association in mind, and without hinging a full-blown rational argument on one, there is a line of thought, or perhaps a path of dots, to be pursued in the connections between the typographical period and the notion of the period as historical era.

One of the questions the preceding interpretation of *Adaptation.* surely invites one to pursue is what periodization provides as a reading strategy. How does a consideration of a historical context's ideological conditions complement an understanding of stylistic operations within a text from that historical period—and vice versa? How does the visual culture of a punctuation mark seem to particularly mediate digital ideologies and aesthetics?

Similar to reflecting on the smaller-scale typographical period, attending to the idea of periodization encourages us to debate the stakes of using one word over another. It forces one to organize one's thought, to determine how to divide and combine units of thought to express them most effectively to others, and to decide where they begin and end, change or continue. Italian philosopher Benedetto Croce writes, "To *think* history is certainly to *divide it into periods,* because thought is organism, dialectic, drama, and as such has its periods, its beginning, its middle, and its end, and all the other ideal pauses that a drama implies and demands. But those pauses are ideal and therefore inseparable from thought, with which they are one as the shadow is one with the body, silence with the sound."[29] Croce's remarks invoke the conceptual intimacy between punctuation and periodization in referring to the concept of pause—one of punctuation's primary functions as it has been identified by those

who have written about the subject, such as M. B. Parkes in *Pause and Effect*. Much as Croce says of periodization, punctuation is a structural necessity, a "silence with the sound."

Or as Marshall Brown puts it, "Without categories—such as periods—there can be no thought and no transcendence beyond mere fact toward understanding. Periods trouble our quiet so as to bring history to life." Summarizing their role in scholarly inquiry, he writes, "We cannot rest statically in periods, but we cannot rest at all without them."[30] In other words, we need to periodize to order thought and make sense of history, but at the same time, we need to resist periodizations. David Perkins claims periods are "necessary fictions. . . . We require the concept of a unified period in order to deny it, and thus make apparent the particularity, local difference, heterogeneity, fluctuation, discontinuity, and strife that are now our preferred categories for understanding any moment of the past."[31] After the insights and demands generated by poststructuralist and postmodernist thought especially (whose very names, dependent upon prefixes, indicate a need to hold on to but move beyond master categories), the unifying perspectives that periodization threatens to impose become opportunities for counterreadings.

Fredric Jameson defends the importance of this kind of idea of periodization for the "exceptions," or what one might think of as the counternarratives, it helps locate. (*Adaptation.,* through its metanarrativity, must surely count as one of the most intricate counternarratives—counter to dot-commania, as I have read it at least—of the early 2000s.) Jameson writes:

> [T]o those who think that cultural periodization implies some massive kinship and homogeneity or identity within a given period, it may quickly be replied that it is surely only against a certain conception of what is historically dominant or hegemonic that the full value of the exception . . . can be assessed. Here, in any case, the "period" in question is understood not as some omnipresent and uniform shared style or way of thinking and acting, but rather as the sharing of a common objective situation, to which a whole range of varied responses and creative innovations is then possible, but always within that situation's structural limits.[32]

The emergence of digital media is deeply embedded in a variety of interrelated categories that have been used to describe periodizing shifts—whether in terms of philosophy or cultural production (postmodernism), social order (network society, control society), epistemologies of materiality (the information age), or technology (computer age), which are echoed in higher education with the recent move toward an interdisciplinary "digital humanities."

In calling attention to digital media's place in periodizing efforts, I am closely aligned with a range of models that posit a historical tripartite structure whose terms, again, differ depending on the overarching goals and contexts of such schema. For scholars of textuality, from Vilém Flusser to N. Katherine Hayles, the major regimes that periodize history are speech, writing, and computation.[33] This schema more or less also forms the backdrop for Brian Rotman's philosophical consideration of human subjectivity's increasingly distributed nature as computational media shift textual systems away from their centuries-long emphasis on writing. Rotman situates the beginning of the end of the "alphabet's textual domination of Western culture" with the introduction of photographic "new media" in the nineteenth century, which began to replace alphabetic representations of information and ideas with visual ones. But, Rotman claims, "this dethroning of the alphabetic text is now entering a new, more radical phase brought about by technologies of the virtual and networked media whose effects go beyond the mere appropriation and upstaging of alphabetic functionality. Not only does digital binary code extend the alphabetic principle to its abstract limit—an alphabet of two letters, 0 and 1, whose words spell out numbers—but the text itself has become an object manipulated within computational protocols foreign to it."[34]

For Hayles and Rotman, then, this new textual situation is about much more than just code. Indeed, it is not code that they are analyzing—it is more accurately a collection of literary texts, critical theories, and historical and scientific discourses. In effect they urge their readers to reckon with code as a form of textual unconscious in contemporary life. What does it mean that the languages

we encounter on computer screens undergo series of mostly invisible translations in coded machine languages? How do knowledge and experiences of this layered effect of machine translations—what Rotman would likely call "ghost effects"—affect, to quote the title of Hayles's recent book, "how we think"?[35] The stakes of this, according to Rotman, are huge. To vulgarly summarize a very complicated argument, he suggests that alphabetic text and its accompanying possibility of imagining disembodiment essentially invented God, and that the dismantling of alphabetic text brought about by digital technologies will have profound consequences for Western monotheism.

While Rotman and Hayles both offer important insights and provocations about human subjectivity, cognition, literacy, education, mathematics, religion, and technology, what I wish to emphasize by calling attention to their scholarship is in many ways a much more basic and obvious component of their more elaborate theorizations. I believe that their most important contributions are ambitious periodizing strategies, the significance of which is only further supported by how wide ranging the spheres of thoughts they connect are and how distributed the consequences of their analyses prove to be. They in effect claim that digital media represent nothing less than a radically new phase in human history, with new epistemological configurations, ideas of the self, formations and relations of bodies, technological infrastructures of communication, and habits of living.

This is also of course the overarching conceptual periodization from which this book's notion of textual shift departs, and I mobilize it to make sense of the changed nature of language systems, practices, and visual culture in the digital age. It allows us to ask what set of qualities characterizes contemporary textuality. The case of the period, this chapter's starting point, demonstrates that as computing technologies have come to trump the printed page as our primary medium of communication, textual protocol shifts.

One key factor that makes this trend possible and also characterizes it is textuality's increased mobility. By mobility I refer to

a range of possible movements, only some of which have been explored in this chapter. From text messages to e-mails, from computer to computer, from one media form to another, from South America to Asia, textuality moves across platforms and locales—in short, what I would refer to as *contexts*—with increasing ease. With this, the range of functions that can be assigned to a given textual inscription expands and is redefined by various users of technologies in different contexts.

At the heart of this new textual period is the networked computer, the technology that makes language's mobility possible. How might we interpret the fact that in this period, the period itself seems to take over society's visual iconography and infrastructural logic? One way to understand the newfound significance of the period, and indeed of punctuation more generally, is in this context of textual travel and mobility. It might be helpful to think of an analogy. When a person travels, it is worth her while to pack for her destination smartly. She does not want to take more baggage than she will need, but she also wants to be prepared for the range of possible weather conditions and activities she might engage in. Versatility and lightness are qualities to strive for. If textuality is traveling as well, these same properties make punctuation marks attractive accessories to pack for the trip, so to speak. Punctuation marks, smaller than letters and certainly smaller than words and sentences, make communication efficient, because they are "lightweight" and can quickly register a mood or tone, but at the same time in many ways they represent what we might think of as floating signifiers, whose meanings and functions can be flexibly adapted for various desired effects.

It is precisely this versatility and lightness that make the period, for example, fit to be widely adapted throughout digital discourses and Internet protocol. Even though it has historically been attached to specific functions in writing, at the same time it is on one level only a dot, so basic and portable that it seems nearly impossible not to be reappropriated. Moreover, when taken to a reasonable level of abstraction, the period's historical function has been syntactical clarity, and thus it makes sense that it continues to hold on to this

function in new ways and for new types of clarity, syntactical and otherwise. These types of clarity include the syntactical, as in the case of the organization of chains of movement in subdomain names and commands. But they also include functions that could be said to offer periodizing clarity in cultural discourse, as in the decimal point that marks the phases of the Web's historical progression from 1.0 to 2.0.

Beyond such textual portability, the period's specific periodizing capacities for the digital should also be thought through in terms of its visual aesthetic—of smallness and roundness—what Peter Sloterdijk might classify as a "microsphere" or bubble.[36] For Sloterdijk, the sphere is a form that represents nothing short of the human condition, our neuroses and our most important questions, from the mother's womb to the planet Earth. He calls for "spherology," a mode of inquiry whose aim "is simply to retrace the formations of shapes among simple immanences that appear in human (and extra-human) systems of order—whether as organizations of archaic intimacy, as the spatial design of primitive peoples, or as the theological-cosmological self-interpretation of traditional empires."[37] Though Sloterdijk does not discuss textuality, his formulation applies to this context. If we take writing to be one of our most important "systems of order," the period would in Sloterdijk's terms be the textual system's microsphere par excellence. Moreover, discourses about the "dot-com bubble" are provocative to imagine in this context: the term is almost redundantly spherical, or perhaps concentrically circular, describing a round enclosure in which cultural activity had its own set of rules and practices, which then burst when pressures and energies from outside proved too strong.

Understanding the period as a microsphere draws it into an even wider context of philosophical problems and intellectual history that might well help provide one final explanation for its pervasiveness in the digital age. If, as so many critics have observed, language has been reduced to zeros and ones, to what extent is the period a closed-in zero-sphere, representing the ultimate reduction of language from complex expressions to two digits to a single

punctuation mark? Viewed from this perspective, the period represents the end of one system of textuality, serving as its ultimate periodizing mark. Or, alternately and perhaps even more provocatively, to what extent does the dot's roundness stand in for a larger sphere, a big world that is now connected, a world whose scale has irrevocably changed and been reconceptualized beyond what other previous periods ever imagined possible? To what extent does the dot compress the large, unwieldy global sphere—what Timothy Morton might call a "hyperobject"—and make it manageable, small, almost invisible?[38] In this sense the digital dot might be better viewed as paired not with zero but with another equally pervasive sphere across the visual iconography of digital media—the world. The period, a self-enclosed sphere, emerges as both a synecdoche for the world but also a more manageable version of it, lending it order and clarity at a time when the globe seems to be spiraling out of control—and when global warming, nuclear terrorism, and other threats on an unforeseen scale seem to be threatening the end of the world, with a finality that exceeds even *Adaptation.*'s crazy ending.

Figure 12. Microsphere/macrosphere conflation? Happy face planet on the cover of *WIRED* (July 1997)

Figure 13. Poster for *Startup.com,* a 2001 documentary about the rise and fall of a dot-com company, where the period becomes a boulder, a suggestive graphic representation of dot-com anxieties

Dotting the I

We might observe that this chapter began with one "holy trinity" in which the period belongs—alongside the other terminal punctuation marks, the question mark and the exclamation mark—and ends with another, where the period stands between the small-scale nothingness of the zero and the global sphere in which we are housed. The discussion also began with reference to a historical decision about typewriter design in 1873, an example where the period was quite literally shifted to the side in technological design, and I have ended it by drawing us in closer to today's concerns, launching us into the digital "period."

For the sake of bringing this chapter full circle, then, but also perhaps refracting it and even spinning it off in a new direction, I will close in not on zero or infinity, but on a personal aside about my own process of typing this manuscript, which has been accompanied

by the added dimension of machine intelligence. In writing this chapter, Microsoft Word's autocorrect feature has continually capitalized words following dots I write midsentence, assuming I intend to punctuate the sentence's end with a period. In this sense, the shift function has now been internalized. The computer automatically performs this "correction" without responding to my own keyboard command, or lack thereof. Yet I have in fact often intended to use the character as a noun (much as the language of the RFCs did), or as part of a noun (as in the case of *Adaptation.*'s title), where in many cases, after the punctuation, my sentence was supposed to continue flowing.

What does it mean that writing is now a battle—or I could be kinder and say collaboration—with a machine? As I write, I not only have to be mindful of managing what I mean and how I express myself, but I rely on Microsoft Word to fix my spelling when I make a clumsy mistake, and I also have to watch out for the mistakes that it makes on my behalf. To my mind, the benefits of its corrections and the drawbacks of its errors, on one level, like the narrative loopholes of *Adaptation.*, cancel each other out. The effect of this, thus, is not so much that machine intelligence makes one's writing qualitatively better, but it makes writing itself a more layered process, with a built-in system of checks and balances between the human and the machine. The nature of this system and its distinctions from prior systems of writing will, as we are drawn deeper into computer age, need to be more sufficiently taken into consideration. One site where this will be especially important is in writing instruction. How will we cultivate in students the common sense, skills, and vigilance required to know when we are right and artificial intelligence wrong? Applying N. Katherine Hayles's elucidation of three different reading strategies—close reading, hyper reading, and machine reading, to be used in conjunction with each other—seems like a promising direction forward.[39] But adopting such strategies on a base level and refining different forms of writing and reading habits will certainly pose ongoing pedagogical questions, which will be scholars' and teachers' responsibilities to tackle as our writing technologies and habits evolve.

2

Within, Aside, and Too Much
On Parentheticality across Media

The previous chapter delineates the period's ubiquity across the visual culture of digital media, arguing that it serves as a periodizing tool for digital culture in general but that its shifting roles also serve as periodizing tools for specific phases of the Internet's history. This chapter similarly takes a single punctuation mark, the parenthesis, as a reading lens to think through the broader textual shift associated with the emergence of digital media and its visual culture. As we will see, the parenthesis presents continuities that bolster the book's broader inquiry into the cultural logic of punctuation in the computer age. Like the period, following the parenthesis allows one to trace a parallel paradoxical visual ubiquity but cognitive neglect of punctuation. Yet it also presents noteworthy differences that draw attention to the specificity of the mark and the ideas it gives rise to, which in turn brings the specificity of the period into sharper focus at the same time. Indeed, the parenthesis inscribes a particular logic that is all its own, found in distinct aesthetic, epistemological, and media contexts. If the period is more tied to a corporate, global aesthetic of digital media's innovation ideologies and postindustrial capitalism, exemplary of what Alan Liu refers to as "information cool," the parenthesis, by contrast, is more apposite to what could be identified as a relative warmth—offering a textual hug—and a logic of alternativity.[1]

Yet this is not to say that parentheses are only found in the margins of culture or are exempt from information cool. On the contrary, parenthetical symbols are largely continuous with the aesthetic. Though we might not think about them much, they are everywhere throughout contemporary media cultures. Think of the smiles and frowns of emoticons, the iconography used for volume control on iPods and MacBooks, the "(RED)" stamp affixed to commercial products that donate money to fight AIDS in Africa, the presentation of "texts from last night" on the amusing website of the same name by area codes in parentheses, and even the laurels that on a film's poster announce its placement and prizes awarded in prestigious festivals. With the proliferation of information about media, too, certain secondary types of details are generally contained by parentheses, such as a movie's running time or rating, the name of a guest musical artist featured on a pop track, or a book's publication information in scholarly citations. Parentheses would seem to be in the most obvious sense of the term floating signifiers, helping to both manage and complicate information, alternately evoking an air of distinction, an independent quirk, the banal, or the cute, along with the gimmicky aesthetics that sometimes accompany these features at the same time, a paradoxical set of qualities perhaps best illustrated by their use in intertitles throughout the stylized romantic comedy *(500) Days of Summer* (directed by

Figure 14. One of many parenthesized intertitles structuring the disjointed narrative of *(500) Days of Summer*

Marc Webb, U.S., 2009) to alert us to the film's disjointed presentation of different days of its protagonists' (non)relationship.

It was not until 2012 that a Google search for a parenthetical mark began to retrieve results for it, and still as of this writing in 2014, somewhat curiously, the top site a search for a single parenthetical mark currently leads one to is *Wikipedia*'s entry for "bracket." This years-long failure to retrieve offers an instructive lesson about what we might think of as the parenthetical's null value, which is perhaps even more effectively illustrated by the frequent scripting of empty parentheses in computer code that many everyday programmers widely perceive as perplexingly useless. Attending to the parenthesis activates movement toward moments beyond the text and drives that have been contained. Such attention also gestures toward a set of questions the parenthetical raises that are particularly related to "new media," a category this chapter in particular will consider and problematize.

Scanning the areas where the parenthesis leads our thought, this chapter employs a mode of critical reading that shuttles between the literal and the figurative (the parenthesis and the "parenthetical"), accounting for epistemological and aesthetic interactions among language, the moving image, and theory in our current moment. In part this reading demonstrates, if in a necessarily aleatory manner, that parentheses have grown in cultural significance, appearing as mechanisms that signal the undecidability, hubris, and materiality of the textual condition. The parenthetical in this sense delineates a conceptual genealogy of postmodernist aesthetics that connects not only issues of writing and language but also of deconstruction, contingency, authority, sound, humor, cultural anxieties, sexuality, narrative, and independent modes of creative production and distribution.

The parenthesis in particular frames that which is set aside within the logic of a given textual protocol, perceived to be too much to handle yet too important to delete. Pursuit of this punctuation mark and the particular cluster of characteristics it represents forges valuable critical space within which we can think through the definitions of new media and especially the roles of theory and

analysis in relation to them. The parenthesis—an inscription that separates insides and outsides and that calls into question the boundaries between them—moves between digital and nondigital, new and not new, and ultimately helps to trouble and shift the distinctions we make in defining and desiring these categories.

Derrida and Deconstruction: The Paren(t's) Thesis?

Vladimir Nabokov's *Lolita* is, depending on the edition, usually at least 300 pages long. In an essay examining the significance of the book's parentheses, Duncan White writes that *Lolita* "is certainly a haven for charged punctuation and more specifically a novel that teems with parentheses: there are a staggering 450 bracketed-parentheses in the novel (that is, opposed to rhetorical asides, apostrophes, and other rhetorical parentheses contained between dashes or commas). This abundance intrigues."[2] By contrast, consider Derrida's "Signature Event Context."[3] By my count, this twenty-one-page essay contains 191 bracketed-parentheses. "Signature Event Context" is, by the most generous estimate, no more than one-tenth the length of *Lolita,* and it features almost half as many parentheses. If Nabokov's use of parentheses is "staggering," how does one begin to qualify Derrida's?

No doubt, such a comparison must be taken with a grain of salt; certainly fiction and theory are very different kinds of writing. However, these figures provocatively suggest that, if one can attend to closely reading Nabokov's parentheses, one way to begin tackling how to read Derrida's difficult writing might be situated in considering the significance—indeed, the necessity—of his reliance on parenthetical form. Probing this issue also stands to offer some insight into practices of critical theory within academic culture, which have themselves inherited parenthetical affectation to a "staggering" degree. This inheritance undoubtedly owes a great deal to Derrida's legacy, writing style, and philosophy.

Many of Derrida's parentheses in "Signature Event Context" do not take on the form of general asides or clarifications, although most do. Many take on the form of enumeration (a parenthesis following a number in a list), many are translations, some are paren-

theses within parentheses (designated by brackets), and a few are
page references. Some are signed clarifications or remarks, such as
the parenthetical signature that closes the essay, and some reflexively
call attention to their own parenthetical nature, as in this passage:

> It seems self-evident that the ambiguous field of the word
> "communication" can be massively reduced by the limits
> of what is called a *context* (and I give notice, again paren-
> thetically, that this particular communication will be con-
> cerned with the problem of context and with the question
> of determining exactly how writing relates to context in
> general).[4]

The fact that Derrida is writing about writing—and in sections such
as this, parenthesizing about parentheses—registers his deliberate
grammatical style. In Derrida's characteristically performative
mode, the reflexive parenthetical of the above passage seems to help
answer our question regarding the significance of Derrida's reli-
ance on the parenthetical.

If, as Derrida directs us in the parentheses, the ambiguity of
"communication" is tied up in the matter of "determining exactly
how writing relates to context," then parenthetical form seems to
be a textual metonym that foregrounds the difficulty in thinking
through writing's riddled relationship to context. By this I mean
to say that the parenthetical is a form that, within written text itself,
invites one to question how writing relates to context, since it sets
apart, disrupts, or postpones the space of the "primary" writing. It
seems safe to say that part of the reason parentheses are important
for Derrida is that they *displace*. They displace the flow and author-
ity of the nonparenthetical.

This sort of parenthetical displacement is critical to Derrida's
project of deconstruction, as he describes it in this essay. He writes,

> Deconstruction does not consist in moving from one con-
> cept to another, but in reversing and displacing a conceptual
> order as well as the nonconceptual order with which it is
> articulated. For example, writing, as a classical concept,
> entails predicates that have been subordinated, excluded, or
> held in abeyance by forces and according to necessities to be

analyzed. It is those predicates (I have recalled several of them) whose force of generality, generalization, and generativity is liberated, grafted onto a "new" concept of writing that corresponds as well to what has always *resisted* the prior organization of forces, always constituted the *residue* irreducible to the dominant force organizing the hierarchy that we may refer to, in brief, as logocentric.[5]

In this passage, Derrida writes about the importance of working—or, more specifically, writing—within the conceptual order, but of simultaneously "displacing" it from within. This act of conformity and nonconformity, of reversal and displacement, is central to Derrida's performance and theorization of language. Following this passage, which comes at the end of the essay, he goes on to suggest that in referring to his own work as "writing," he has engaged in this very act of reversal and displacement with writing itself. While there is always meaning in writing, there is also always a field of forces in which writing generates more than meaning; writing is, in Derrida's language, "non-saturated" ("generality, generalization, and generativity"—the generation of the "genera-" in his phrase is a continuing expansion and mutation of language, signaling the precariousness of generalization, which slipperily turns on itself—as a generative act of production and as a generalizing act of category-covering, of contextualizing in a broader sense).[6]

In Derrida's spirit, then, *parentheticality* can name a philosophical concept that borrows a typographical metaphor to strain upon the limits of non-saturation, as a way to explore how language, grammar, and displacement might apply to figuring activity in the cultural realm. Parenthesis, in Greek, means "to place in beside." What, in culture—in our lived practices and relations—is placed in beside? The use of parentheses brings to mind subordination and displacement in discourse, as by definition, they can, but need not, displace grammatical order. Historically, too, attention to them seems to be best characterized by subordination. Theodor Adorno, in his essay on punctuation, contemptuously issues a caveat against their use: "The test of a writer's sensitivity in punctuating is the way he handles parenthetical material. The cautious writer will tend to place that material between dashes and not in round

Figure 15. Parenthetical proliferation: a photograph of four pages of Derrida's "Signature Event Context" side by side, with text whited out and just parentheses highlighted

brackets . . . , for brackets take the parenthesis completely out of the sentence, creating enclaves, as it were, whereas nothing in good prose should be unnecessary to the overall structure. By admitting such superfluousness, brackets implicitly renounce the claim to the integrity of the linguistic form and capitulate to pedantic philistinism." He proceeds to liken the use of parentheses to "shutting" language "up in a prison."[7]

In another essay examining rhetoric about parentheses, mostly in literary handbooks, Robert Grant Williams observes that "the parenthesis exemplifies the marginalization of certain figures—particularly schemes—since not only has little been said about the parenthesis, but what has been said . . . sounds strikingly denigrating and dismissive. From the Renaissance to the present, value judgments have obfuscated the ways in which the parenthesis generates

meaning, and often have wheedled themselves into definitions of this figure."[8] Consider two examples from recent cinema and film criticism. At the end of Roger Ebert's four-star review of *(500) Days of Summer,* he includes a "note" to his readers: "The movie's poster insists the title is '(500) Days of Summer.' Led by *Variety,* every single film critic whose review I could find has simply ignored that punctuation. Good for them."[9] Or, in a pivotal scene from another of 2009's most critically acclaimed films, *Up in the Air,* Ryan (George Clooney) discovers that Alex (Vera Farmiga), with whom he has been having an affair, has a family she did not tell him about. Immediately afterward we see Ryan (figure 16), looking down and riding in a train, receive a mobile call from Alex, inside a parked car. She says, "I thought our relationship was perfectly clear. You are an escape, you're a break from our normal lives. You're a parenthesis." Ryan responds, "I'm a parenthesis." Alex: "I mean, what do you want? Tell me what you want." The sequence cuts to Ryan, forlorn, unable to speak. We return to Alex: "You don't even know what you want." She goes on, while Ryan, holding back tears and unable to say more, hangs up in silence. In a film widely praised for its screenplay, this is one of the most cited scenes, referred to in various commentaries as the "parenthesis scene." Joseph Natoli reads it as containing the movie's moral: "One way of looking at the movie—call it the 'constructive' way—is to think that Bingham learns in the course of the movie that when you avoid the serious in life no one makes you a serious part of their life. You become as Alex, a woman he assumes is as totally an air borne wanderer as himself, no more than a parenthesis in another's life."[10] The parenthesis, in other words, is a metaphor for the metaphor of the film's title and theme: being "up in the air," living lives increasingly in transit and online, connected but disconnected. Whether or not we find the scene as heartbreaking as we are supposed to, there is no question that Farmiga's comment is a devastating blow for Clooney, signaling the slightness of his place in her life.

We might bring such popular perceptions into contact with theoretical arguments for the productivity of studying marginalization and think about what Williams identifies as the parenthesis's

Figure 16. George Clooney as Ryan Bingham in *Up in the Air*'s "parenthesis scene"

"marginalization"; we might, in effect, read the parenthesis *into* intellectual histories. Foucault writes, for example, "Silence itself— the things one declines to say, or is forbidden to name, the discretion that is required between different speakers—is less the absolute limit of discourse, the other side from which it is separated by a strict boundary, than an element that functions alongside the things said, with them and in relation to them within overall strategies. There is no binary division to be made between what one says and what one does not say; we must try to determine the different ways of not saying such things."[11] Foucault's stress on the different ways in which silence operates "alongside" and "within" nonsilences, and its *not* operating in terms of strict separations and boundaries resonates in the context of a consideration of the parenthetical, as curved lines whose very shape resists rigid, linear boundaries, and as a punctuational structure that brings into flux the boundaries between saying and not saying things.

To invoke a common example of this latter point, observe whether when a speaker reads passages of texts aloud, the reader chooses to articulate parenthetical text or to skip over it. She or he often pauses briefly and seems uncertain as to whether or not to read it. Regardless of whether it is spoken, most of us following along likely read the parenthetical text. Why is it that we read the parenthetical but only sometimes speak it? This uncertainty indicates that parenthetical text is an intriguing case for thinking about the ways we imagine the relationships that exist between silence,

(declining) speech, writing, reading, and their dynamic discursive fields.

Within parentheses, the writer can get away with writing what he might not otherwise be able to write outside of them (a joke, a value judgment). Writers can use them to write something that crucially clarifies what they might not have felt was appropriate to explain outside of them. Writers can use them to displace not only grammar but also their tone of address. Finally, it seems that in parenthetical space, the writer is also allowed to convey herself as a noncohesive subject. In readings throughout the Nietzschean genealogy of cultural theory through Foucault and Derrida, one can observe the importance of this writing strategy, which one might trace back to the incertitude and reflexivity of Nietzsche's own writing, in which the text's author engages in conversation with himself, doubting the authority or coherence of what the writer just wrote. Nietzsche writes in *Genealogy of Morals,* for example, "Am I understood? . . . Have I been understood? . . . '*Not at all my dear sir!*'—Then let us start again from the beginning."[12] He then proceeds to start his essay over again. While this text is not physically *in* parentheses, one might certainly understand it as interrupting the text and its movement in a parenthetical manner. In fact, one might make sense of much of a work such as *Genealogy of Morals* by applying the notion of parentheticality to it, as the text hovers between different tones and voices, without always distinguishing them from one another grammatically.

Parentheticality does not occur only in written texts; its recessive generativity offers a framework for moving beyond the text and thinking through other, nontypographical things that circle in its conceptual orbit: comedy, sexuality, narrative form, affective cues, value relations, cultural hierarchies, and taboos. In the next two sections of this chapter, I turn to two primary examples from audiovisual media in American culture: the sitcom laugh track and the film *Me and You and Everyone We Know.* In divergent ways, both cases seem apposite to the concept of parentheticality in literal, textual, and cultural senses of the term. Even though typography figures in both cases, there is no reason why parentheticality

needs to draw upon written parentheses; here they add texture to thinking about the concept's dynamics.

(Laugh track.): Parenthetical Anxieties

How, then, might the logic of parentheticality take shape as a cultural form? Its logic is particularly resonant in the intersection of comedy and sound: the parenthesis as a structure, as we have observed, is especially suggestive of the relationship between sound and silence; and on top of this, the parenthetical is a textual site where a joke can take place, where the text is able to laugh at its own discourse and puncture its own seriousness. For these reasons, the televisual laugh track could be understood to be an exemplary manifestation of parenthetical cultural logic.

When asked by a BBC reporter to compare deconstructionist philosophy to *Seinfeld,* Derrida, seemingly taken off guard and unfamiliar with the series, responded, "Deconstruction in the way I understand it doesn't produce any sitcom. And if sitcom is this, and people who watch this think that deconstruction is this, the only advice I have to give them is just read, stop watching sitcom and try and do your homework and read."[13] While his response implies that popular television was outside his field of interest and not of significance to understanding his philosophy, in this quick dismissal, Derrida might have given the endless openness of his philosophy more credit. The ideas we have just revisited and developed in relation to the parenthetical resonate particularly when we pause to take the laugh track seriously. Moreover, the cultural anxieties the track registers open up a line of thought upon which we can consider the status of new media and its relation to the parenthetical—itself offering a parenthesis of sorts within this book's broader focus on the digital.

There is a volume of television criticism, *The Show and Tell Machine,* written by Rose Goldsen, that speaks to the laugh track's stigmatization in popular culture. In her brief chapter on the laugh track, Goldsen goes into great detail about how the laff box works. She explains how it is played like an organ, that it can make almost

an infinite number of different laughing sounds, and that it requires high-level skill to operate. She then writes about the laugh track in animated series:

> The laugh track is built into the factory-made animations no less than the shows performed by live-on-film actors performing before live-on-film audiences. Bugs Bunny engages in his usual antics with Elmer Fudd. (Laugh track.) An animated doctor car pours medicine into the carburetor of an animated car that is ill. (Laugh track.) A bumbling Great Dane is chased by a caveman. (Laugh track.) The Addams Family enters a baking contest and uses alligator eggs to make the batter. (Laugh track.) Pebbles and Bamm Bamm are chased by a weird-looking prehistoric creature. (Laugh track.)[14]

Goldsen describes various scenes of animated gags. Then, after each sentence, "laugh track" gets its own grammatically incomplete, parenthetical sentence. The words are repeated identically each time, even though she acknowledges in the same pages that the possible sounds it can generate are nearly infinite. In other words, she never writes, "(Guffaws.)" or "(Explosion of whoopers.),"[15] only "(Laugh track.)." This writing of the laugh track seems to reflect how we imagine the track parenthetically—invariably, grammatically separate, an aside.

Goldsen's literal parentheses bring to mind a more figurative parentheticality that helps make sense both of the laugh track's sonic suturing into the rhythm of the sitcom and of its place in cultural consciousness more generally. The sound of prerecorded laughter, coming from the position of the audience—structured into the soundtrack of the television program—interrupts or displaces the principal flow of the program. But at the same time, its very interruption becomes integral to a show's flow, in a manner similar to the function of a parenthetical in a written sentence. In this spirit, Rick Altman has referred to the laugh track in passing as an "audience within the spectacle."[16] Indeed, the idea of the parenthetical as a form that allows for the shifting of the cohesion of the articulator within the articulated is very much in line with Altman's

characterization of the laugh track—and with Derrida's theory of writing, as well.[17]

One of the most notable opponents of the track was Larry Gelbart, *M*A*S*H*'s creator and writer. Gelbart adamantly protested the track's deployment in the series with CBS network executives, who wanted to use it consistently throughout the show. CBS eventually decided to compromise and agreed to keep it out of scenes that took place in the operating room, but they insisted that it be engineered into all other scenes.

Gelbart's *M*A*S*H* production files contain a manuscript written by him in pencil, which reads:

> Gene [Reynolds] and I fought two of life's unnatural forces, the network and the studios, for the right to deal with bolder subjects than they were inclined to allow. We wanted to explore the effects of violence, examine pro-war attitudes, adultery, pain and death, impotence, homosexuality, race relations, a never-ending list of topics not generally considered subject for comedy.
>
> Most of those battles we won (as our ratings climbed, network resistance fell). Our most notable loss was on the matter of the laugh track. ~~that insidious practise, They~~ CBS would never let us do away with it no matter what other compromises they were willing to make. So there it is, on almost every episode, ~~a machine reacting~~ a recording of ~~recorded reaction to every funny line, a good many~~ people guffawing at material they never heard, a good many of them long dead. The only thing I ever learned from the track was that while I can't be sure of life, we all have a chance at a laugh after death.
>
> Except for that, we achieved a creative freedom that is unheard of in the medium. We needed as much as we could get, for there was an ongoing restlessness about trying different ways to dramatize our material.[18]

Gelbart's own cross-outs in his description of the laugh track (not unlike Goldsen's writing of the track) can be taken as symptomatic of its aside-ness in cultural discourse. Moreover, these notes take on an even more striking position of parentheticality in the

context of their relationship to their own transfer to publication. The specifics of this history were not deemed necessary enough to tell *M*A*S*H*'s "complete" history, as it is excluded from Suzy Kalter's quotations of Gelbart's words in the essay "The Making of *M*A*S*H*," which she includes in her *The Complete Book of M*A*S*H*. What she attributes to Gelbart in the essay instead is the following:

> "The network was not anti about our being anti-war. They were antiheavy and antiserious," Larry Gelbart says. "Most of our battles with them stemmed from the fact that we wanted to veer so far from what was considered half-hour comedy. They called us up periodically to have it out with us. While the cast and crew were out at the Fox Ranch fighting the elements, Gene and I fought two of the most unnatural forces in the world—the network and the studio—for the right to deal with bolder and more serious subjects than they were inclined to allow, like the effects of violence, adultery, amputation, derangement, impotence, homosexuality, transvestism, and interracial marriage. Most of the battles with Army brass on the screen came out of our battles with the network."[19]

Read in juxtaposition to Gelbart's note in the original manuscript about the laugh track being their "most notable" lost battle with the network, his reference in the published material to wanting to break free from conventions of half-hour sitcom is clearly primarily about the laugh track. It is quite telling that the very documentation of this debate is left unarticulated in the official version of his words. The laugh track's omission here resonates with its underregarded status in popular culture and, for media scholars, also with its largely overlooked position as an object of media studies.

Historically, the deployment of the track and its reception have been bound up with anxieties that might be characterized, and made sense of, by the track's being haunted by the sounds of possibly dead people laughing. As Gelbart's notes suggest, it seems that these anxieties (among others) are closely connected to the ways in which we tend to overlook and disdain its presence in sitcoms. The presence or absence of the laugh track in a TV series often becomes an

inverse marker of how publics perceive the show's quality.[20] This is increasingly an especially popular and accepted opinion today, as many contemporary, critically acclaimed comedies—*The Simpsons, Arrested Development,* and *The Office,* to name a few—do not deploy the track. This more social and historical characteristic of the laugh track, too, seems capable of benefiting from a conceptualization of parentheticality: recall Robert Williams's observation that the "parenthesis exemplifies the marginalization of certain figures."[21]

Indeed, the laugh track seems to mark American cultural imagination as something that is best forgotten and ignored: in a Derridean sense, as a sort of structured absence, as a parenthetical. In one of the only published historical analyses of recorded laughter, Jacob Smith writes, "the laugh has been presented as the ultimate expression of the human, and its mechanical reproduction serves as a lightning rod for anxieties concerning authenticity and the social dimensions of mass media consumption."[22] To extend Smith's convincing and researched argument, I would propose that the laugh track likely becomes worth overlooking discursively as a means of managing the anxieties that it induces and reveals. These are fundamentally about sonic nonsaturation and the uncertainty of context—the possibility, for example, of hearing a long-disassembled audience's laughter recorded at a *Red Skelton Show* pantomime skit, worked into the rhythm of Americans fumbling through the Korean War (by a sound engineer in a Fox studio in the 1970s), and then heard in a rerun syndicated for your home entertainment in the twenty-first century.[23] On DVD, viewers have the option of turning *M*A*S*H*'s laugh track off entirely, adding a new dimension to the unresolved debates and anxieties indexed by these documents' parentheses, cross-outs, and neglected words.

In other words, by dint of its status as recorded and reusable, fixed and moving, the laugh track's temporality extends indefinitely, much like Derrida's theorization of writing's ontology. Here this case study of the laugh track's parentheticality stands to offer perspective on and pose questions about our conceptualizations of "new media." The laugh track represents the embedding of the old in the new. The uncanny, parenthetical presence of the old in the

new, of the human in the machine, inscribed by television's prerecorded laughter, represents a structural possibility of temporal layering found across all media texts and forms, which Derrida reminds us is ontologically part of every inscription. A logical extension of this claim is that the "new" of "new media" is necessarily relative. All media are at once new and old, depending upon our vantage point—a valuable lesson many scholars have suggested in recent work, perhaps most compellingly by Lisa Gitelman in her comparative framing of Edison's nineteenth-century phonographs and the history of Arpanet in the twentieth century as new media.[24] This is not, importantly, to dismiss "new" as a categorical marker: debates about the laugh track's use in *M*A*S*H* in fact prompt us to move toward a potentially useful, relational understanding of "new media" in which the new incorporates the old, rendering it parenthetical: staying there, but on the side, making us uneasy.

))<>((: Inside Out and Back and Forth

If the laugh track's parentheticality foregrounds the necessarily relative and vexed temporality of the new, I will now explore another multilayered reading of the concept that turns it inside out, while foregrounding digital iconography. Miranda July's film *Me and You and Everyone We Know* (2005) seems to articulate, and to be articulated by, a variety of parenthetical forms and qualities.

An appropriate transition from *M*A*S*H*'s laugh-track optional DVD feature and entry into this discussion might be found not in the final film itself but in looking at the deleted scenes on its DVD. Each of these scenes that has been deleted from the film, but which parenthetically remain in the movie's digital packaging—as "special features" for the viewer to watch at his or her discretion—stars children. In one, Peter (Miles Thompson) scolds his brother, Robby (Brandon Ratcliff), for pooping outside, and he goes into great detail recounting stories about the dangers of human poop in the animal environment. In another, Sylvie (Carlie Westerman) shows her parents one of her dolls, and they tell her that the doll looks like it will grow up to be a prostitute. A third, titled "Lesbian Mom," shows three girls making believe they are family in a schoolyard, and Sylvie grows jealous of the other white girl's claim to be

the black girl's mother, so they decide that they are lesbian mothers, but Sylvie whispers to the black girl that she is the mother who gave birth to her. It is quite suggestive that these scenes are each in different ways exploring children's worlds and their (il)logics, and exploring how they play out in relation to, and especially prior to, socialization. These might be read as being "too much" for the film to handle—be it because of their treatment of two difficult social issues at once (race and homosexuality), or because Sylvie's parents are depicted too negatively and the film ultimately aims to depict its characters in a less indicting fashion. The film itself, though, very effectively (in my opinion) works through what is "too much" and how to make it not too much. In this sense, the film is exploring a Derridean sort of parentheticality: how to expand what is articulated within a given context, how to displace conceptual order, and how this, through "writing," creates "new" writing.

Moreover, the writing that takes place with "new," digital media is central to the film's themes. One of the film's memorable subplots involves an agrammatical use of parentheses, which become windows into the film's open-minded treatment of the ways in which human—particularly childhood—interactions and relationships are inflected by digitally mediated cultural practices and psychologies in contemporary society.

Two of the film's young characters, Peter and Robby, seem to spend most of their free time being socialized into the world on their shared computer. In one scene, they sit in their bedroom, enter a chat room online, and talk to an anonymous user. Peter is suspicious that the user is not really a woman, since, he asserts, people always go into chat rooms and pretend to be people they are not. They ask her about her "bosom," which Peter mispronounces in explaining to Robby. Robby, the younger of the two, then suggests they write to her that their Internet personage wants to "poop back and forth": that he will poop into her butthole, that she will poop it back into his, and that this will proceed "back and forth. Forever." The woman they chat to is intrigued, to Peter's surprise. A few scenes later in the film, we see Robby on a public computer, presumably in a school library, and he is instant messaging with the woman again. She writes to him that she has "been thinking about the 'back and forth.'" The chat proceeds:

Untitled: Do you remember what you said the last time?
NightWarrior: I [Robby cuts and pastes "remember" from
Untitled's message] remember. The poop.
Untitled: Yes, the poop.
Untitled: It makes me want to touch myself.
Untitled: Is that very bad?
NightWarrior: Maybeeeeeeeeeeeeeeeeeeeeee
Untitled: Sounds like you're excited too.
Untitled: I am touching my "bosoms." What are you doing?
NightWarrior: I am drawing
Untitled: OK . . . Drawing what?
[Robby looks at a sketch he made of pooping back and forth
at the beginning of the conversation.]
NightWarrior:))<>((
Untitled: Huh?
NightWarrior: Back and forth.
Untitled: I get it. When can we meet?

NightWarrior's parenthetical expression goes on to do some traveling.

We discover that the untitled woman turns out to be the art gallery curator, Nancy Herrington (Tracy Wright), whom Christine Jesperson (Miranda July) has been trying to contact to review her artwork. On the poster for Herrington's multimedia digital art exhibition at the end of the film, we see "))<>((" reprinted as the exhibition's tagline, thereby serving as a ;-) to the spectator, since the only characters in the film that would recognize the expression would be Peter and Robby, who are not at the gallery.

Figure 17. Chat screen in *Me and You and Everyone We Know*

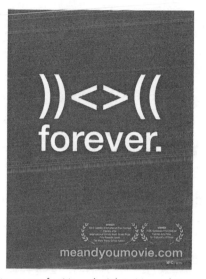

Figure 18. Publicity poster for Miranda July's *Me and You and Everyone We Know* (2005)

"))<>((," followed by the word "forever," was also essentially the film's own tagline. It is featured in one of the film's two primary publicity posters—the text in large font stands alone as the poster's only image—and in the film's T-shirts. An uncredited website, backandforthforever.com, has twenty screens one can move through (back and forth), which contain images of Miranda July–like messages written on a static television screen and three photos of a large banner with the expression "))<>((" hanging and held up in public spaces. Given the expression's origin, its reappearance in these various diegetic and nondiegetic contexts helps drive home the film's themes of connection and loneliness in our ubiquitously digital era. Moreover, it also drives home the film's suggestion that the art show within the film parallels the film itself: July, a performance artist—who plays a performance artist in the film—in effect opens an internal parenthesis. Both the film and the exhibition depicted within it are exploring these themes, and the very double-mediation of these again foregrounds the same themes of contemporary communication and awkward technologically mediated human connections that "))<>((" evokes. (Recall Derrida's

parenthetical comment about communication and the question of context. Here, the parenthetical expression's serial regression might be taken as exemplifying Derrida's outline of the problematic of the parameters of contextualizing.[25])

As one of the film's most memorable exchanges, this nongrammatical use of parentheses to stand in for the butt, and more generally the nongrammatical use of parentheses and other punctuation marks in instant-message communication, is a case where punctuation is not used for what it means but for what it looks like. Rather than being used grammatically, it becomes useful for creating expressive imagery, such as emoticons. New-media practices such as text and instant messaging thereby reappropriate grammar's textuality, typographically inflecting culture—as opposed to the way the laugh track might inflect cultural imaginations in a more grammatical manner. (I would point out, though, that both the laugh track and the emoticon are affective cues: imagine a flashing smiley face punctuating a sitcom, telling us to laugh.) *Me and You and Everyone We Know* intelligently captures the strange, imaginative impact such new processes harness upon our everyday lives and psychologies.

Significantly, the reappropriation of parentheses originates in the film with a six-year-old's communication to an adult. In an interview July conducted when *Me and You*'s production was in progress, she explained, "I'm trying to figure out how to have a romance between an adult and a child that isn't offensive, that somehow gets it. Because it is something that exists in the world, even though we can't deal with it. It's almost a symbol of what we're not getting to have because of fear and systems based on fear."[26] Perhaps it is not completely arbitrary that *Lolita,* the most exemplary child–adult love narrative, also "teems" with parentheses. The hesitant, displaced space and tone of the parenthetical might prove useful to narratives that explore sexual encounters between children and adults, to help "reverse" and "displace" the "conceptual order" that determines what is sexually acceptable. If one were to pursue this Derridean reading, one might read the very inversion of parentheses in *Me and You* as a gesture to make the uncomfortable more comfortable, much as July attempts to do in general with her

nonjudgmental and genuinely curious treatment of children's sexuality. Indeed, when the parentheses are turned inside out, we are dealing with what we cannot deal with (and likely laughing about it, too, not least of all because punctuation marks representing poop are between them and outside them at the same time).

It seems, then, that one could read the film's parentheticality in a figurative sense of the concept as well, on both narrative and cultural registers. In her *Los Angeles Times* review of the film, Carina Chocano writes, "Miranda July's gorgeously loopy *Me and You and Everyone We Know* is made up of . . . nonsequiturs that make perfect sense, banal images that turn transcendent on a dime, casual exchanges that seem to encompass the entirety of human relationships." (Is the parenthesis not a loopy nonsequitur?) Chocano goes on, "July takes a world in which everything ugly is a distinct and lurking possibility—rejection, stagnation, lack of money, sex between adults and teenagers, virtual coprophilia, your true love dumping you because she's dying—and turns it into an oddball love song."[27] One might read the film's narrative as a series of parentheticals—a series of asides that depict sexually curious, childishly innocent, and seemingly inessential parts of its characters' lives.

These sorts of encounters do not generally make up the dominant fabric of plots in American cinema, whose narratives tend to be limited by—or tightly and economically woven around, depending upon one's point of view—sets of conventions that reiterate particular unions of romantic relationships between characters, as much film scholarship stemming from Laura Mulvey's observations in "Visual Pleasure and Narrative Cinema" has critically analyzed over the past forty years.[28] To apply Foucault's phrase for rules governing representations of sexuality, we might understand the film as "putting" the cultural and sexual parenthetical "into discourse." Outlining his work in *History of Sexuality,* he writes, "What is at issue, briefly, is the over-all 'discursive fact,' the way in which sex is 'put into discourse.' Hence, too, my main concern will be to locate the forms of power, the channels it takes, and the discourses it permeates in order to reach the most tenuous and individual modes of behavior, the paths that give it access to the rare or scarcely

perceivable forms of desire, how it penetrates and controls every-day pleasure."[29]

With several plotlines about these various parenthetical social practices and states, particularly the frequent interspersing of chil-dren's explorations of sexuality throughout the narrative of a ro-mantic comedy presumably motivated by the reconciliation of an adult man and woman, the film in effect relies on these practices' parentheticalities (their marginalized/set-aside statuses) in order to bring their very parentheticality to the fore, and to demonstrate—in tandem with Foucault's theory of the history of sexuality—that their liminal positions are perceived as deviant only in specifically constituted social and historical contexts. These contexts include codes that regulate the conventions of classical Hollywood story-telling, which have ideologically and considerably carried over into postclassical American cinema. Along these lines, an IMDb user attends to the movie's dynamic narrative silences and perceptively observes, "The movie is notable for what isn't in it—both malice and pain are almost absent. Removing malice—July's world is one in which a kid can safely walk alone through some seedy parts of Los Angeles—is unfashionable, brave and, given the gentle tone of the piece, necessary. But the absence of pain isn't intentional: July would like us to feel the loneliness of the characters."[30]

In this way, then, one can understand the film's parenthetical inversion in the expression "))<>((" as representative of the film's narrative parentheticality in a more general sense, in that the film consists almost entirely of parenthetical content, diegetically invert-ing the very rule of the parenthetical: that it is set aside from, but within, dominant discourse. In other words, in *Me and You and Every-one We Know,* the parenthetical becomes the dominant, so that a map of the film's plot looks like:

$$X(a)X(b)(c)(d)(a)X(d)X(b2)X(a)(d2)X(b)(a)X(c)X(b)X(a)$$
$$X(d2)(a)X(a).$$

"X" represents strands of the narrative that revolve around Chris-tine and Richard Swersey's (John Hawkes) coming together as a romantic couple, and the parenthetical letters represent the various scenes that feature children learning about the world they live in

(where "a" stands for Robby's Internet exploring, "b" for two girls' flirtation with an older shoe clerk, "c" for groups of children at school, and "d" for Sylvie, a young neighbor of Peter and Robby, who obsessively collects items for her dowry in a large chest).

One might follow the outward pull of July's parentheses even further. It would be instructive to distinguish *Me and You*'s narrative parentheticals from a more modernist cinematic parenthetical: the classic sequence in Godard's *Band of Outsiders* (1964), where Godard's three protagonists unexpectedly break out in a dance in the middle of a café (since quoted in *Pulp Fiction*). We might remember that as Odile, Franz, and Arthur dance, though we continuously hear the diegetic sound of clapping and feet moving on the floor, music cuts out of the sound track, alternating with a narrator's voice that announces: "Parenthetically, now's the time to describe their feelings," proceeding at intervals to describe the sexual and otherwise invisible desires of each character. For Godard, this parenthetical, which calls attention to the discrepancy between sound and image, is one of a variety of techniques used regularly throughout the film to expose the cinematic apparatus.

July's parentheticality thus instantiates a cinematic evolution from the thorough anti-illusionism of Godard's modernist filmmaking to a postmodern formal experimentation and trademark "quirk" *within* more or less familiar conventional narrative structures (here of the romantic comedy) that audiences have come to expect of independent cinema and the interlocking stories that characterize what David Bordwell calls "network narratives."[31] Bordwell identifies *Me and You* as a key example among many recent network narratives, alongside films such as *Short Cuts*, *Pulp Fiction*, *Magnolia*, *Crush*, and *Babel*. While it certainly shares a postclassical, multistranded narrative style with these films, grouping them together obscures *Me and You*'s distinct stylistic sensibility and feminism. While the other films for the most part are overdetermined, July's storytelling is distinctly feminist, playfully whimsical. Though the "Everyone We Know" of July's title would seem to suggest an affinity with the global ambitions of other network narratives (Bordwell himself grapples with how to read the film's title in this context), it is significantly underdetermined, directed by a woman with

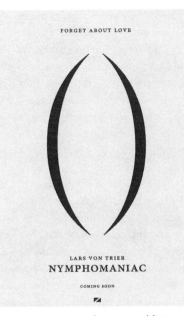

Figure 19. Sexually suggestive parentheses in publicity posters for Lars von Trier's *Nymphomaniac* (2013)

a demonstrated interest in non-feature-length and multimedia forms of storytelling. July's idiosyncratic film shares more in common with the modes of video art, short story prose, and feminist punk rock that she has been involved with over the course of her career than with the films of Tarantino, Altman, or Inárritu. Breaking down *Me and You*'s narrative, we see that the parenthetical in a sense becomes the very dominant that the structure strives to displace.

The affinities of the parenthesis more generally with indie aesthetics that one finds across independent cinema and indie rock here coalesce into the foreground. Musical examples of parentheses include Sigur Rós's 2002 album *()*, The Blow's 2006 "Parentheses" single, and the band Parenthetical Girls (contradictorily and playfully composed of three men and one woman), active since 2004. Notable cinematic examples include *Me and You, (500) Days of Summer, (Untitled)* (directed by Jonathan Parker, U.S., 2009), and the suggestively sexual O formed of two parentheses in the

middle of the title in advertisements for Lars von Trier's *Nymph()maniac* (Denmark/Germany/France/Belgium/UK, 2013). Von Trier's parenthesis is especially evocative, not only of the mark's ability to visually stand in for body parts (here, the labia). It also typographically suggests (1) the film's symmetrical structural division into two volumes, the second of which could be seen to be much more "maniacal" than the first more "nymphic" half, and (2) the textual symbols appearing within the film, which punctuate the image with superimposed numbers and words that complement themes of the storyline. These inscriptions within the film serve to render the story on one hand more serious, connecting it to the chain of classical, philosophical, historical, mathematical, and literary references cited and alluded to in the film's framing story. (And of course the framing device itself could finally be viewed as lending the film a parenthetical structure, where the characters parenthetically comment and reflect on the stories Charlotte Gainsbourg's character shares.) Yet at the same time these textual inscriptions are playful, forming conscious jolts *out* of a spectatorial suspension of disbelief that the unpunctuated image track seduces us into. This wave of titles, bands, songs, and films featuring parentheses all emerge after 2002, after *Adaptation.* and the collapse of dotcommania ideologies outlined in the previous chapter—as if to suggest the parenthetical serves as a metaphor for a new waiting period in media culture, as if to ask whether this is a phase *of* or *against* the digital (it is telling in this context that The Blow's album featuring "Parentheses" is called *Paper Television*). The appeal of the parenthesis across independent media cultures is that it comes between, goes both ways, and thus stands for embrace and resistance at once.

Postmodernism, New Media

To close, we might return to the issue of the enterprise of critical theory. Indeed, this chapter largely emerged out of an encounter with Derrida's essay on intersecting visual and cognitive levels: observing patterns of ink on paper while reflecting on his arguments about text, context, philosophy, and communication. Why, I asked, using "Signature Event Context" as a defining example, do so

many texts of critical theory rely so heavily on parentheses in their prose? I have offered some speculative answers to this question, which I believe are related to the deconstructive impulse: to unravel language and to expose its inherent contradictions. We should read critical theory's parentheses as bearing Derridean traces, but also as tools for identifying and marking continuities and ruptures in intellectual histories and paradigms. As Fredric Jameson notes, performatively in parentheses himself, in *Postmodernism, or, the Cultural Logic of Late Capitalism,* "One of the concerns frequently aroused by periodising hypotheses is that these tend to obliterate differences and to project an idea of the historical period as massive homogeneity (bounded on either side by inexplicable chronological metamorphoses and punctuation marks). This is, however, precisely why it seems to me essential to grasp postmodernism not as a style but rather as a cultural dominant: a conception which allows for the presence and coexistence of a range of very different, yet subordinate, features."[32]

The parenthetical and the parenthesis, from television's laugh track to the instant message's emoticon, resonate with postmodernism more generally because they challenge textual authority and master paradigms. We might even say that the parenthesis makes the very reading of postmodernity's break with modernity legible. From Rosalind Krauss's sustained engagement with parentheses as a model to describe the ontology of video and instant feedback in her influential essay in the first issue of *October* to Jean Baudrillard's reference to the automobile as a "sublime object" opening a parenthesis "in the everydayness of all other objects," the parenthesis figures as a recurring, if little noticed, metaphor in seminal works of cultural criticism since 1968.[33] Jean-Louis Baudry, writing in his canonical 1970 essay of film theory, for example, uses the mark as a metaphor to explain the phenomenological encounter with the cinematic apparatus, "At the same time that the world's transfer as image seems to accomplish this phenomenological reduction, this putting into parentheses of its real existence (a suspension necessary, we will see to the formation of the impression of reality) provides a basis for the apodicity of the ego."[34] Such passages suggest the agency thinkers were beginning to find in textuality to account

for, critique, and especially render visible cultural formations. Perhaps most representatively and even more recently, in "Why Has Critique Run Out of Steam?" Bruno Latour reads modernity itself as a parenthesis:

> My point is thus very simple: things have become Things again, objects have reentered the arena, the Thing, in which they have to be gathered first in order to exist later as what *stands apart.* The parenthesis that we can call the modern parenthesis during which we had, on the one hand, a world of objects, *Gegenstand,* out there, unconcerned by any sort of parliament, forum, agora, congress, court and, on the other, a whole set of forums, meeting places, town halls where people debated, has come to a close.[35]

In this widely circulated essay, Latour admirably attempts to rethink the foundations of the entire field of the history of science that he played a central part in shaping. In the context of the disavowal of global warming and the emergence of the 9/11 Truth movement, to which we might wish to add more recent critiques of the Republican Party as the "Post-Truth Party," Latour holds himself accountable for promoting this same alarming cultural logic that denies truth. He calls for a future of critical thought that is stubbornly realist and empirically grounded.

Though he argues for clarity, this passage admittedly remains somewhat opaque. What exactly does Latour mean by the modern "parenthesis"? He seems to suggest that we have arrived at a point of return, back to the way things were—a premodern, preprint, and, in some respects as Latour freely admits, fantasized intellectual history. The model he posits, put simply, is *premodern (modern) postmodern,* where these terms visualized in sequence help suggest the parallelism between what lies on the parenthetical marks' outer sides: the prefixed modern. Latour's "modern parenthesis" relies on a familiar visual model, whose closure is suggestive of a return to a prior stage—picking up where the parenthesis was opened—and whose epistemological incertitude also allows us to entertain the provocative notion he coined elsewhere that "we have never been modern" in the first place.[36] In this context, the implication of the

parenthesis, then, is that the "modern" might only be a placeholder for the real epistemological need at the heart of the matter: periodization. (And the "period," after all, is the final punctuation mark.)

By extension, this chapter has suggested that rather than understanding "new media" as historical forms collapsed definitively (with a period) into the decades that see the emergence and evolution of digital technologies, it could be useful to understand the "new" of "new media" as parenthetical. In other words, the necessity of "new" is questionable, always fundamentally relational, bound up with anxieties, value judgments, and gimmickry, but also with potentials to subvert, rethink, and displace the status and authority of what lies on the parenthetical's other side—in this case, "media." For example, the common aversion to the use of the laugh track could be understood as anxieties over the relationship between the new and the old: in terms of Goldsen's and Gelbart's historically situated anxieties in the 1970s, when the track was a fairly "new" technology; in terms of the track featuring "old," dead voices laughing; or in textually relative terms as a "new" element inserted into a program. These questions, I hope to have demonstrated, are most productively understood as relational, discursive, and thus epistemologically parenthetical.

Brought into more explicitly digital contexts, whether in the surfaces of emoticons, graphic designs, and word documents or in the depths of computer code, contemporary parenthetical marks could be read as historically layered with previous parenthetical inscriptions' structural possibilities, discursive tensions, and performative politics. In this sense, we might therefore view the parenthesis as a mark inscribing the very legacies and possibilities of the status of critical theory for visual culture today. More than any other mark, it channels Barthes's *punctum* into the current moment, unexpectedly offering a way of reading the shifting nature of textuality in the computer age, at least as I see it.

Visualizing textual ruptures, the parenthesis brings the relationship between media and theory into focus, or perhaps more properly, into question. The proliferation of and play with parentheses in popular culture, whether in writing, as metaphors, or as icons, tends

to wager on the punctuation as marks that embrace and connect, but as we have seen, they also shore up the loneliness, anxieties, and fears that structure the recessive undersides of the utopian connections and dominant myths of modernity—and now, in what quite possibly looks like a return to a time we might have never left, of the new media age.

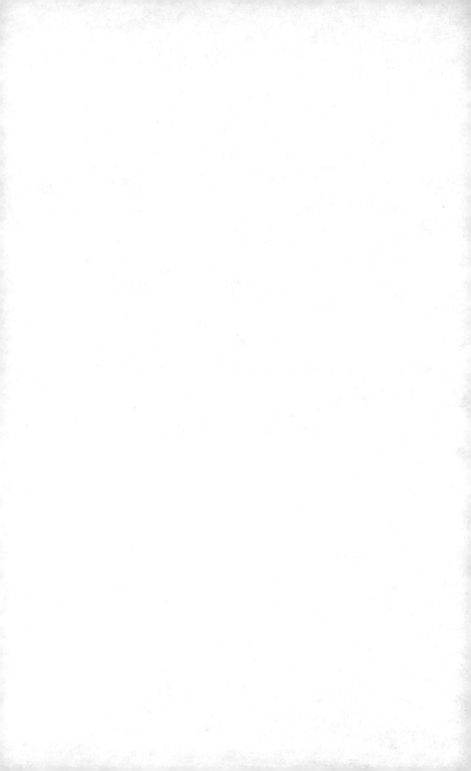

3

Logic

Hashtaggery

The preceding chapter marks a transitional parenthesis in this book's larger account of textual shift, with the parenthesis's grammatical, symmetrical, and in-between allure. Regarding punctuation and digital textuality, too, it is transitional within this book's flow. Unlike the period examined before it, the parenthesis relies on the computer's shift key for its inscription. In this chapter I turn our attention to a character that relies on the shift key as well but that, unlike the period and the parenthesis, is less strictly a punctuation mark in the conventional sense, though some historical accounts in this chapter's purview have explicitly and implicitly referred to the # symbol as punctuation in suggestive ways. Just as the preceding chapters mobilized characters as reading lenses for comparative media analyses, this chapter also examines a string of texts, technologies, and phenomena that the # symbol calls our attention to and that in turn expand our understanding of the cultural logic of the symbol—and ultimately of punctuation more generally. Precisely insofar as the # mark straddles conceptual boundaries of punctuation more than the period and the parenthesis, this chapter will allow us to home in on and conclude the book's broader inquiry by interrogating and refining our understandings of what punctuation even is, particularly as it intersects with and is

informed by media history, visual culture, and the digitization of the world.

It seems only appropriate to pick up after the book's parenthesis with a character (of the nontypographical sort) who was central to the ending of the preceding chapter on the period: Susan Orlean, the *New Yorker* writer who penned *The Orchid Thief,* the basis for *Adaptation.* Shifting focus from orchids to the hashtag, she published a piece titled "Hash" on the topic in June 2010 for the magazine's blog. She muses at the outset, "The semiology and phenomenology of hashtaggery intrigues me." Orlean observes in the piece with trademark *New Yorker* wit and cultural insight,

> Hashtags have also undergone mission creep, and now do all sorts of interesting things. Frequently, they are used to set apart a commentary on tweets, sort of like those little mice in the movie "Babe" who appear at the bottom of the frame and, in their squeaky little mouse voices, comment on what you've just seen and what you're about to see. A typical commentary-type hashtag might look like this:
> "Sarah Palin for President??!? #Iwouldratherhaveamoose"
> This usage totally subverts the original purpose of the hashtag, since the likelihood of anyone searching the term "Iwouldratherhaveamoose" is next to zero. But that isn't the point. This particular hashtaggery is weirdly amusing, because, for some reason, starting any phrase with a hashtag makes it look like it's being muttered into a handkerchief; when you read it you feel like you've had an intimate moment in which the writer leaned over and whispered "I would rather have a moose!" in your ear.[1]

Orlean's blog contribution productively begins to critically unpack the unique tone that belongs to hashtag-preceded tweets, a form of textuality that has spread far beyond Twitter and seeped into all forms of writing, and even into speech and music—culminating in a popular subgenre of hip hop, "hashtag rap" and a pattern of speech frequently embraced and parodied by Jimmy Fallon in late night television. Orlean's humorous comparison of tweets to *Babe*'s mice recalls the "audience within the text" that we considered in the

previous chapter's discussion of the laugh track's parentheticality. Indeed, the "whisper" of a tweet that Orlean describes in many ways suggests a striking affinity with the parenthetical, where both instances of inscription articulate an author's personal and often humorous response to the more official language that precedes it. In this sense, the hashtag and the parenthesis both serve to set textuality off, indicating to the reader the presence of a personal reflection from the writer.

But the difference between them is crucial. The intimate, handkerchief-muffled tone of the tweet is projected in a forum that by its nature is anything but intimate. It is public, and in practice the hashmark makes the message it accompanies accessible to a large audience of friends, followers, and digital strangers. The hash's *tagging* function is a key characteristic of the mark's shifted textual circulation in digital contexts. The symbol indexes whatever phrase follows it alongside all other tweets that contain the same phrase,

Figure 20. Taco Bell food poisoning joke on Neil Hamburger's Twitter page

allowing users to group and locate information that belong to a common topic, theme, or mood—hence facilitating everything from the recent trend in marketing and quantitative studies to conduct "sentiment analyses" of the networked community at any given moment to the ability of comedian Gregg Turkington's Neil Hamburger character to retweet hundreds of messages about Taco Bell food poisoning from a myriad of users and dates at once to create a comedic but also trenchant glimpse into American society.

The American Dialect Society voted the word *hashtag* to be 2012's "word of the year," signaling the pervasiveness of the term not only in Twitter but across the Internet and in everyday life. Voicing widespread sentiments, Lindy West writes of the mark's hold on popular culture, "Just a couple of years ago, our little friend # was nearly irrelevant, relegated to the lonely domains of foam fingers (we're #1!) and robocalls (press # for more options). But these days, along with its boyfriend @, # is leading the charge in the Twitter Revolution (#SorryISaidTwitterRevolution). Hashtags have changed the way we think, communicate, process information. In all likelihood you're hash-tagging something right now. # is everywhere. # is inside you."[2]

A particularly instructive moment occurred in early 2013 when France's Commission générale de terminologie et de néologie officially banned the English word in official documentation and replaced it with *mot-dièse,* the French equivalent for "sharp word," referring to the musical sharp key's sign. The commission's objective, since 1996, has been to preserve the French language's purity, largely by keeping English words out of the language as much as possible. As such, one of their tasks is to encourage "the presence of the French language on social media networks."[3] Though the effort to not passively step aside and watch as global English imperializes the world's other languages is admirable, it is also worth tuning in to the skepticism registered by those who have suggested that this political commission's energies are misguided and out of touch. Will official banning of the language in documents truly have sway over vernacular that has already existed for several years? Does the slightly inaccurate translation, since the musical sign and the hashtag slant in different directions, demonstrate a disconnect with

digital culture? Perhaps more crucially, to what extent is such an effort denying the reality of Global English and the way it constitutes and structures the languages and logics of networked communication? That a national governmental organization went to the trouble to ban the use of the word *hashtag* indicates the extent to which the phenomenon is "everywhere" and "inside" us.

To write that the symbol is "inside you" is suggestive of the manner in which the # sign harnesses a cultural logic, of how it represents a way of thinking that has deeply penetrated cultural consciousness. One might reflect a bit further on the ontological nature and phenomenological consequences of this strong impact. Does it mean that we now think in keywords—and that we previously did not? Does expressing our thought in keywords or hashtag punchlines come at the expense of other forms of expression that have different dimensions and textures of experience? It might at first seem tempting to associate the # sign's cultural hold with a bad turn—a decline, a lack of sophistication, a loss of literary complexity, or even of literariness itself.

"#Hashtag," the most popular skit in the history of *Late Night with Jimmy Fallon,* as measured by its online viewership with over

Figure 21. Jimmy Fallon and Justin Timberlake making hashtag finger gestures on *Late Night with Jimmy Fallon* (September 2013)

23 million views in its six months on YouTube as of early April 2014, offers an illustrative *mise en scène* of these cultural anxieties. This skit imitates—and exaggerates—the incorporation and inter-penetration of social media discourse into everyday discourse. Fallon and regular guest Justin Timberlake perform a conversation in which hashtag discourse feels like it outweighs nonhashtagged discourse, so that, for every phrase spoken, there seem to be two or three hashtags the performers offer. The effect of this is, of course, irritating, as confirmed by Questlove's closing quip, telling them to "hashtag shut the F up." The skit's overwhelming popularity certainly indicates that viewers identify with this irritation. Indeed it was so popular that Fallon did a very similar sequel to the skit in his first week hosting *The Tonight Show* a few months later with guest Jonah Hill, which featured a cameo by Martin Scorcese.

Both scenes' ratios of tags to nontags register anxieties about the impoverishment of communication—how meaningful statements and thoughts now seem to be drowned in a sea of keywords, accompanied by a shortened attention span and a paradoxical mode where people seem connected but not really—one strand of conversation hardly builds on the previous one, and rather language just seems to accumulate, go nowhere, punctuated and emphasized

Figure 22. Martin Scorcese making a cameo (and a hashmark) on a reprised hashtag skit on *The Tonight Show* (February 2014)

by the finger pound, crossing the index and middle fingers of both hands to visualize the hashmark. The deterioration of the conversation in the original skit is most fully realized when the final exchange between Timberlake and Fallon is just composed of sounds, nonwords to the tune of a Missy Elliott song, interrupted by Questlove, with his own finger pound.

These skits provocatively lay bare, to quote Marquard Smith's recent claim, that in our current moment, "*all* content has become largely irrelevant. What matters," he writes, "is not *what* is gathered, arranged, and transmitted, but *how* such gathering, arranging, and transmitting works. 'What' is supplanted by 'how.'"[4] The Fallon–Timberlake exchange and particularly discussions about it illustrates this perfectly: cultural commentators and various casual conversations I have overheard about it in public do not mention *what* Fallon and Timberlake actually talk about—cookies, Mona Lisa, Miley Cyrus, or *Orange Is the New Black*. Rather it is a vessel for metadiscourse, for talking about how we talk with hashtags in popular culture. This is why the skit resonates.

A regular viewer of Fallon's shows might find that the host's critique of this habit is undermined by his frequent use of the hashtag as a means to engage with the audience: every week on *Late Night,* for example, he orchestrated the "Hashtag Game," for which he would coin a hashtag and invite home audiences online to contribute the preceding statement to which the hashtag belonged, reading a handful of his favorites on air. However, it makes sense to read this as consistent with the Timberlake skit's critique, as an attempt by Fallon to cultivate thoughtfulness about how to use the mark properly and wittily. Indeed, Fallon is often admired and distinguished above and beyond his late night peers for integrating digital trends and social media into television.

Contributing to the chorus of conviction that we are deeply under the influence of the symbol found across popular texts to more highbrow cultural criticism, Piper Marshall writes for *Artforum,*

> The temperament of our generation can be summed up by the hashmark. If the '90s were full of "quotation marks" indicating irony, a decisive sarcasm and a distance from the opinion of norms, our current climate is dominated by pithy

punch lines that summarize the solipsist's always already uploaded narrative. The hashtag is the redemption of Internet statements—written to be read by everyone you know, obviously. Until they are recycled via a chaotic circuit of retweets, reposts, and reblogs, eventually rendered as vapid as that ubiquitous Facebook prompt: "What's on your mind?"[5]

Marshall suggestively takes as an assumption that the hashmark is punctuation, situating its affective trajectory as following on the heels of another generation's signature marks—1990s' quotation marks—foregrounding their analogous inscription of cultural zeitgeist.

One might note that the four fingers used to figure the hashmark, as the five performers in Fallon's two hashtag parody skits all gesture, are the same pairs of fingers used by speakers to indicate quotation marks. In her 2003 book *Quotation Marks,* which is very much about and symptomatic of the prior decade's cultural fascination with quotation, Marjorie Garber discusses the tendency to "flex the first two fingers of each hand, miming the look of (American-style double) quotation marks on the page," observing that "the two-finger flex has become conventional rather than strictly mimetic, a sign of quoting rather than a quote-sign."[6] Her subsequent reference to this gesture as "digital quotation" is a useful reminder of the close etymological and historical ontological relationship of fingers-as-digits, our bodily counting organs, to the digital, the numerical, computerized infrastructure of our media systems. Both hand movements notably involve the two index fingers, quite literally figuring a shift in digital indexicality, where the index (finger) no longer points to a referent but in fact gestures to an absent, metaphorical text.

This continuity from quotation marks to hashmarks is surprisingly generative to consider. Social media's hashtags have in a sense become repositories of quotations. Think for example of what happens when a celebrity dies. Various other celebrities tweet their responses and condolences, and journalists then draw on these remarks, turning them into quotations used in longer-form obituaries. The same goes with reportage of current events: politicians' tweets become sound bytes used to texture coverage of current events and in effect construct historical narrative. In other words, a distinctly late-twentieth-century cultural fascination with

quotation, which was just as much about truth and authority as an ironic skepticism in them, finds its social media outlet in Twitter, where these same issues are still felt but transfigured. Namely, the voice and position of authority have become diluted, the iterations of the story have been amplified and more quickly replaced by the latest trending topic—indexed by hashmarks.

To read the quotation mark as a predecessor of sorts to the hashmark thus affords a useful opportunity to remember the historical and cultural contexts that it seems so often tend to be elided in conversations about new media that focus on the nowness of the present, or what Wendy Chun calls the "enduring ephemeral."[7] Marshall's comments—emphasizing "retweets," "reposts," and "reblogs"—also point to the impossibility of making sense of the hashtag's significance outside of the context of textual proliferation. According to Marshall, the marks offer the promise of the possibility for our tiny words to seem significant and clever when they might otherwise seem lost in an endless flow of discourse. This significance relies on being *indexed* and on the possibility of being found.

If periods and parentheses draw attention to the proliferation of textuality in digital contexts, then hashmarks continue to do so, while at the same time, like the others, demonstrating how this proliferation is *managed by* punctuation marks as well. Indeed, this managerial feature is one of the striking roles the period and the parenthesis play in digital culture—from the period's structuring of domain names to parenthetical bibliographic references. If in print culture punctuation helps manage *semantically,* clarifying textual meaning, then in digital culture there is a distinct shift whereby punctuation now helps manage more *syntactically.* While punctuation in human languages certainly has syntactic functions, the important distinction is the loosening of its semantic functions. Semantic displacement represents a more general textual shift that punctuation is metonymical for: to an informational, instrumental, and short-form computer-oriented textuality from a narrative, expressive, and long-form book-oriented textuality.

The hashmark's popular use on Twitter, a social microblogging website composed of updates famously limited to a maximum of 140 characters, provides an opportunity to further condense the

most salient topic of an already short message into a keyword, a phrase, or a string of keywords and phrases. In this sense, the hashtag represents what is arguably the single most pronounced feature of new textual practices: the brevity of communication and expression.

This textual condensation is further highlighted by the elimination of spacing between words that come after a hashmark. Spacing is itself ontologically and historically bound to punctuation. As pure but deliberate textual emptiness, spacing could be considered punctuation's most basic manifestation. Writing before around 1000 AD was conventionally in *scriptio continua,* meaning that texts were presented in a continuous stream of letters, with no word separation or punctuation. As M. B. Parkes explains, text presented in this style "required careful preparation before it could be read aloud with appropriate pronunciation and expression. Rendering a text in *scriptio continua* proceeded from identification of the different elements—letters, syllables, words—through further stages to comprehension of the whole work. Reading at first sight was thus unusual and unexpected." He elaborates further,

> The merit of *scriptio continua* was that it presented the reader with a neutral text. To introduce graded pauses while reading involved an interpretation of the text, an activity requiring literary judgment and therefore one properly reserved to the reader. In ancient Rome readers of literary texts were mostly a social elite, whereas full-time scribes were usually freedmen or slaves (Atticus kept slaves to publish Cicero's work). Quintilian observed that many things to do with reading could only be taught in actual practice: when a pupil should take a breath . . . , at what point he should introduce a pause into a line of verse . . . and where the sense ends or begins. . . . All of these are situations which we would expect to be indicated by punctuation as we understand it now; then, a reader had to analyse the phrasing of a text before he could read it properly.[8]

Thus the return to the elimination of textual space that occurs with increasing frequency in digital culture (routine in web addresses for example, but culminating par excellence in hashtags)

foregrounds provocative affinities with ancient textual practices, bringing into focus the relationships among literacy, clarity, social status, textual neutrality, and perhaps most interestingly—on an ontological level— a reintroduction of an increased level of interpretation that takes place while reading. To what extent, for example, does being able to read a tweet depend on a technological literacy that has been cultivated to know how to insert pauses between words? The brevity of a tweet is mostly not comparable in terms of textual complexity to a story conveyed on ancient scroll, but such a comparison is worth considering if only to weigh the nature of the continuities and discontinuities digital textuality presents against previous forms of writing. Like *scriptio continua,* the tweet demands mental activity of separating on one's own to make sense.

Of course with hashtagged script, unlike *scriptio continua*, nonspacing coexists with spacing. As such it is discourse that visibly inscribes the simultaneity of machine and natural languages. One could thus read the elimination of spacing in the digital context as registering an antagonism between the human and the machine, a result of the human being forced by technical protocol to confine text to a limited space. Condensation becomes an almost frantic response to pressure, cramming in what one needs to say while one has the chance, without taking a breath, so to speak.

If the management of textual proliferation and the brevity of digital communication practices mark two primary features composing the cultural logic of the hashmark, then a third central feature of its logic could be conceptualized as a changing multidimensionality of language throughout digital textualities, characterized by a simultaneous interaction of the horizontality of human languages with the verticality of computer languages. The intersecting horizontal and vertical lines of the symbol could be understood to visualize this condition. On one hand, an overwhelming number of Internet users know how to use the mark. Yet on the other hand the hash symbol's function of indexing metadata, of collecting and hyperlinking all other expressions that contain the word or phrase tagged, points to a computational process that the majority of us understand the effect of but which depends on our reliance upon a series of computational operations that are largely invisible,

inscrutable, and too technical for the majority of Internet users to understand—or to *want* to understand.

Viewed from a more distant vantage point, this procedural logic represents an extension of the principle of apparatus theories of cinema that were popularized (and more recently popularly criticized) in 1970s film theories inspired by a particular confluence of Marxism, psychoanalysis, poststructuralism, and feminism. One's encounter with a website such as Twitter, like one's encounter with a given cinematic text, is facilitated by a range of technical processes invisible to the eyes and "smoothed" over; these processes facilitate experiences with the media interface and our psychological immersion into its platform. (Or, in describing the Internet, "immersion" might be better substituted by passing, browsing glances.) Indeed, if film theory's point was that our encounters with cinema are shaped by ideologies inscribed in the structural situation of the cinema and the material, technical components that constitute cinematic spectatorship, then so too one could think of the ways in which our encounters with new media texts are shaped by ideologies inscribed in computing systems and software.

In the more specific context of digital textuality, the operative principle of the hashmark can be viewed as exemplary of what Espen Aarseth has identified as the "dual nature of the cybernetic sign." Mobilizing semiotic vocabulary to describe this duality, Aarseth identifies the *scripton* as designating the sign's surface image and *texton* as referring to its underlying code.[9] Implicitly or explicitly, a range of observations by textual scholars echo the logic of this distinction, whose contradictions are forcefully channeled into the hashmark's singular character. N. Katherine Hayles, for example, coins what could be reappropriated as the catchphrase for this situation in arguing for media-specific analysis: "print is flat, code is deep."[10] Though Hayles means to draw attention to the differential nature of the printed page and the electronic text, one might also make sense of this difference as constituting a differential dimensionality *within* all digital texts, as they remain visual like the printed page but contain an added, "deep" dimension of code.

Alexander Galloway pinpoints this logic of the digital inscription in his response to Wendy Chun's reflections on software and

ideology. He asserts, "Language wants to be overlooked. But it wants to be overlooked precisely so that it can more effectively 'over look,' that is, so that it can better function as a syntactic and semantic system designed to specify and articulate while remaining detached from the very processes of specificity and articulation." "This," he goes on to explain, "is one sense in which language, which itself is not necessarily connected to optical sight, can nevertheless be visual."[11] Galloway thus suggests that the digital situation is one in which language looks at us—*we* in a sense are the objects of visual culture, of the text's gaze—in a structural inversion of cinematic apparatus theory. This potential is perhaps most fully realized when one stops to think about the highly technical and legal language of agreements on applications and software we sign off to with virtual signatures by clicking "accept" in order to become "users." This language, too, we could surely say, wants to be "overlooked" to "look over" us. The "language" one then inputs on popular social media websites like Facebook, via status updates, because we have probably not fully thought through the consequences of these agreements if one even does take the time to read them, provides endless data for intelligence agencies and corporations who use personal information for monetary gain and social control.

One could articulate the quality of the textual condition that I am describing as follows. If Marquard Smith claims that *how* today supplants *what,* I would slightly revise this formulation: increasingly, *that* supplants *what.* We know *that* the system works and we know how to use it, but we *don't* know how it works. The formulation usefully posits a replacement of a different linguistic order: rather than one question replacing another (from what to how), *that* suggests a uniquely removed relation to knowledge, where we do not question it—perhaps the question mark is, as Michel Gondry's *Is The Man Who Is Tall Happy?* implied per the book's introduction, not digital after all. Similarly, we know *that* information is accessible via the Internet, but we do not know the actual information it holds without it. Alongside social media relatives like the Google search and the Facebook status update, the Twitter hashtag represents this new relation to information, knowledge, and memory, part

of what Bernard Stiegler would characterize as the "informaticiza-
tion" of knowledge, whereby digital media's "memory industries"
are supplanting the primacy of human consciousness—and even
"life itself."[12] We do not need to remember details, we only need
a keyword to lead us through a chain of links and to the specific
details that we can browse through, doing our best to determine
what information we need or want and what information is dis-
posable. The cognitive practices associated with this have been
studied widely and seem to characterize a significant shift in the
life of the mind in the "information age." Information moves from
being stored in our minds to being stored in our machines, while
we refine our skills for searching, indexing, and knowing where
to find stored data. The full extent of the ideological consequences
of this shift—and the exact extent to which it characterizes a
shift—remain to be witnessed and understood. Our fingertips, typ-
ing on our keyboards, mediate our access to knowledge.

One of the most provocative theorists to discuss and forecast
this situation is perhaps the Czech writer Vilém Flusser, who pre-
sciently observed the emerging historical consequences of computer
memory upon members of a computerized society. Consider for
example his remarks in "The Non-Thing 2":

> Until quite recently, one was of the opinion that the history
> of humankind is the process whereby the hand gradually
> transforms nature into culture. This opinion, this "belief in
> progress," now has to be abandoned. . . . The hands have
> become redundant and can atrophy. This is not true, how-
> ever, of the fingertips. On the contrary: They have become
> the most important organs of the body. Because in the situ-
> ation of being without things, it is a matter of producing and
> benefiting from information without things. The production
> of information is a game of permutations using symbols. To
> benefit from information is to observe symbols. In the situ-
> ation of being without things, it is a matter of playing with
> symbols and observing them. To program and benefit from
> programs. And to play with symbols, to program, one has to
> press keys. One has to do the same to observe symbols, to
> benefit from programs. Keys are devices that permutate sym-
> bols and make them perceptible: *viz*. the piano and the

typewriter. Fingertips are needed to press keys. The human being in the future without things will exist by means of his fingertips.

Hence one has to ask what happens existentially when I press a key. What happens when I press a typewriter key, a piano key, a button on a television set or on a telephone. What happens when the President of the United States presses the red button or the photographer the camera button. I choose a key, I decide on a key. I decide on a particular letter of the alphabet in the case of a typewriter, or on a particular note in the case of a piano, on a particular channel in the case of a television set, or on a particular telephone number. The President decides on a war, the photographer on a picture. Fingertips are organs of choice, of decision.[13]

Flusser conceptualizes a *non-thing* as that which cannot be held by the hand, and so in a computer-based society, the information contained within our machines is untouchable and non-thing. He argues therefore that we are increasingly "without things." While some of his remarks stand to be complicated by a more nuanced understanding of digital media's material conditions and coded infrastructures, Flusser's comments nevertheless register the importance of attending to what one might think of as the surface effects of digital media, configured in the interactions of materiality, the body, keys, symbols, and computing technologies. Flusser's early interest in such surface effects are particularly relevant (and also poetic) for understanding a punctuational symbol like the hashmark, a character that appears on buttons millions of people press everyday. What "happens existentially" when on our computers we hold down the combination of the shift and 3 keys to inscribe the # sign or when we scroll our mouse over a hashtag to click on it and uncover related themes? What "decisions" do we make?

The use of the shift key takes for granted, for example, a certain familiarity with the keyboard, insofar as in its current design, there is no intuitive means to discern that the characters written directly on top of the number keys are inscribed by pushing the keys in conjunction with shift. The current keyboard thus relies on a (relatively basic) socialization process and learning curve

whereby one gets accustomed to "playing" it like a musical instrument, learning the correct combination of buttons to achieve desired effects. I call attention to this practice more for rhetorical effect than to offer definitive answers or claims about phenomenology and digital media, but these questions provide an opportunity to think comparatively and historically about various media forms, technologies, and their relationships: from the soundscapes created by musical instruments and the telephone through the letterscapes of the typewriter and the computer.

Indeed, Flusser's comments here and elsewhere about textuality, design, the body, playing with symbols, and the necessity and significance of fingers pressing keys can form a transition to delve into another moment that more closely coincides with his own, staging a juncture of continuities and ruptures with the hash symbol's present pervasiveness. The symbol's logic can be radicalized by juxtaposing it with an earlier moment of "new" media—when the number sign was introduced to touch-tone telephones in the late 1960s and early 1970s.

The Telephone's Octothorpe

According to a Western Electric document on file at the Bell Laboratories archives, the company manufactured 6,700,000 # buttons in 1972 alone.[14] This number of number signs is a useful reminder that the button and the symbol on it have substantial presence throughout the history of media technologies and their audiovisual cultures. Is it possible that the sign's uses in previous technological contexts such as the telephone's made possible a cultural context in which it could be redefined and popularized by Twitter? How and what, in other words, might the mark be able to illuminate about cycles of culture—how and when certain practices ebb and flow, how and when certain ways of thinking congeal and are reconditioned? As Flusser's comparative perspective reminds us, we use buttons to make decisions on telephones and computers alike.

The operator's recorded voice instructing the caller on the line to "press pound" is now a commonplace feature of our uses of telephones, but, of course, it was not always. A *Bell Labs News*

article, "New Phone Buttons Offer Instant Banking, Cooking," announces in March 1968 the Bell System's plan to add two buttons to its touch-tone telephones "to get ready for the push-button world of tomorrow."[15] Until that point, their telephones contained ten numbered and lettered push buttons for dialing. The two new buttons introduced were of course the asterisk in the lower left and the number sign in the lower right of the keypad, sandwiching the zero, provocatively situating them as if they are nonsignifying characters like the zero, unlike numbers and letters with positive values.

At the time the buttons were introduced, they would have indeed seemed to be nonsignifying. As the article's author explains, "For the time being, they have no function. But when some of the future TOUCH-TONE services become available, the two new buttons will be functional." It would be too easy to equate the buttons' nonfunctionality with nonsignification, however. Not only could the buttons be viewed as signifying nonfunctionality itself (which must be understood as distinct from nonsignification) but, more accurately, they signified the promise of innovation in an unknown future. The announcement proudly declares that "a businessman will be able to check computerized inventories of his merchandise, or a bank clerk can adjust accounts by tapping out information that his TOUCH-TONE set will feed into a centralized store of bank data." Enthusiastically anticipating a future in which "many more custom-designed services will be available," the author writes, "The two new buttons will be used to operate these new services. The shopping housewife, for example, might dial her home number and then push the asterisk button to start her electric oven." The asterisk was of course never developed for "instant cooking," but the two buttons did take their place as telephone keypads' eleventh and twelfth buttons, taking on routine uses in various automated services on telephone calls.

One thus encounters a historically recurring assumption that punctuational characters serve as floating signifiers, easily adaptable to a range of situations in which designers and cultural innovators might wish to put them to use. The flip side of this semiotic flexibility is that their context-dependence also threatens their value,

rendering them nearly ontologically void. However, a more specific phenomenon comes into play as well: as the marks become standardized into digital contexts, they are increasingly able to signify in isolation, thereby losing a semantic flexibility but gaining in return an increased visual mobility.

Moreover, we see here how the telephone's potential is marketed to a wide audience, while drawing on heavily gendered discourses and expectations prevalent in the 1960s, imagining a male businessman or banker and a female housewife. One might think of the female operator's voice that, as the sign's function did historically develop, instructs callers to follow data commands by pressing the pound key, receiving and processing commands from an implicit male, helping make the service provided more efficient. Such a gendered dynamic is continuous with a long-standing structuring dynamic of women as professional "computers" or "programmers" since the very first computing systems were configured in the 1940s, which seamlessly extends into the continued imagination of the near future.[16] In 2013's Academy Award–winning *Her* (directed by Spike Jonze, as if to substantiate the presence of *Adaptation.*'s digital subconscious discussed in the first chapter), for example, Scarlett Johansson voices Samantha, the disembodied, Siri-like operating system with whom Joaquin Phoenix's character falls in love. As so many critics have noted explicitly and viral parodies implicitly suggest, *Her* is resolutely not *Him*.

Figure 23. *Her* (directed by Spike Jonze, 2013): continuing the fantasy of the feminized machine

Figure 24. Introducing the number sign to the touch-tone telephone.
Courtesy of AT&T Archives and History Center

The pound sign, in other words, could be contextualized within this gendered history of new media and punctuation, where the user tells the automated female voice that his command is complete, and she can take over, helping him get whatever he needs to get. Pressing the pound sign is an authoritative command, coming at the end of a data transfer, signaling the transmission's completion, of often important and often private information, such as a password or a credit card number. The expectation of entrusting this kind of personal information with a feminized machine signals the ways in which, historically, women have been assumed to be more reliable and trustworthy than men.

In a note addressed in 1991 to William Safire on file at the AT&T Archives, which one could infer to be a direct response to his *New York Times Magazine* "On Language" entry "Hit the Pound Sign" of the same year, James Harris, a Bell Laboratories employee who was part of the team that introduced the two symbols to the touch-tone telephone, attempts to "put a bit of history on the record" about the # button. He explains that he and others at the Laboratories wanted to take "advantage of the fact that a touchtone 'pad' could be made to produce twelve different signals almost as easily as the ten that were in common use; the two extra signals (buttons) would be identifiers and punctuation for the data message."[17] Harris's references to the symbols as punctuation usefully invite

us to consider an expanded notion of punctuation that approaches a range of typographic symbols as behaving like punctuation, what I call *loose punctuation,* a conceptual invitation that the number sign instantiates. His use of the term might simply refer to the mark's status as a nonalphanumerical character, but more than that, it also seems to register a sense of stopping and starting, of making data more readable, the way punctuation does in natural languages.

Harris recalls,

> It was fairly easy to agree on the asterisk. . . . The great problem was the naming of the lower right button. . . . I would have preferred a simple dot or period, but our professional human–factors people held strongly that a dot could be confused with an asterisk and did not have sufficient distinctiveness. Way back then the many names we were aware of for "#" included octothorp(e) and lumberyard and, of course, pound mark and number sign. I was reluctant to go with the number sign (as I think of it) for three reasons: First, its name is a source of undesirable confusion. Second, for those people who do think of it as a number sign, the mind is preprogrammed to *use* it as a number sign; this may be different from the meaning in the particular protocol that is in use. Finally, thirty years ago I was deeply concerned with worldwide standardization, and I was concerned that some typewriters and keyboards around the world lacked the "#" symbol, thus denying their users the ability to type out the DIVA format.[18]

Given the symbol's eventual frequent use as finalizing the transmission of a code, it is interesting that Harris wanted to make the key a period. He points to ways the two symbols are in a sense kindred spirits, where the pound is the period's less linguistic cousin—since it does not have a linguistically traditional role as punctuation in human languages, something which, after Twitter, is now changing. Along these lines, the symbol repeated three times is also used to mark the document's end in press releases or typed manuscripts.

The status and etymology of the term *octothorpe* itself is shrouded in a bit of mystery. Some writers claim that *thorpe* means village, and the symbol visually represents eight *(octo)* fields surrounding a

village. Whatever its true origins, it seems to have been a jokingly and internally used nickname at Bell for the number sign. While some writers claim that the proper term for the sign is "octothorpe," various employees in the telecommunications industry insist that the symbol's name is emphatically not "octothorpe" but "number sign."

A Western Electric news memo titled "A Story about #" seems to in fact be a memo that plays into the company's internal joke about the sign. Its author references a quote from a nonexistent poem by Shelley B. Percey, "To a Number Sign": "Hail to thee, blithe Symbol / Octothorp though never wert," riffing on the line in the poet's "To a Skylark": "Hail to thee, blithe Spirit! / Bird thou never wert." The document also discusses a man, Charles Octothorp, who "decided one day to find a way of making his family name famous. His strategy was simple, but effective. He'd approach anyone with a Touch-Tone phone, stop, look closely and say admiringly: 'Golly, that's a remarkably handsome octothorp you've got there.'" After detailing an elaborate story about this man's effort to deceive a gullible public, the author asserts to the reader, "When you encounter these people and hear their misusage, correct them. Tell them the truth—that the '#' on the Touch-Tone button made

Figure 25. "MY NAME IS NUMBER SIGN." Courtesy of AT&T Archives and History Center

by Western Electric is called a 'number sign.' "[19] This is accompanied by a cartoon illustration of a personified number sign with an angry face in the middle of repeating for a fourth time on a chalkboard the phrase "MY NAME IS NUMBER SIGN" (figure 25). Reading the exact tone of this memo is difficult: it does not read straightly as an instructional memo, nor is it entirely a joke. Somewhere between the two, it captures a certain geeky, technophilic attitude that nevertheless reflects a serious concern.

For Harris, the stakes of naming the sign include historical accuracy, which would also seem to be the stakes inscribed in Western Electric's documents, though in a roundabout way, via its perversion of history with the fictional character Charles Octothorp. One could thus read this fiction as playing provocatively with the symbol's mysterious and debated history, and its ongoing shifting status in technological contexts.

It is also worth considering further what Harris refers to as "worldwide standardization," since various international keyboards were not equipped with number signs. The sheer variety of terminology for the symbol speaks to the ways in which the number sign in particular registers national differences. It has been called the lumberyard in Sweden, the cross in Chinese, a hex in Singapore and Malaysia, hash in Britain, and pound and number in the United States and Canada, just to name a few. Harris's concern was not treated as significant cause for choosing an alternate symbol, suggesting that those (Western) nations with the symbol on their keyboards would likely find themselves at a technological advantage when services provided by touch-tones would become more widespread. The recent decision by the French government to replace all official mention of the word *hashtag* with *mot-dièse* thus presents a provocative continuity with concerns over uses and naming of the symbol favoring English-language operating systems. In both cases, what might seem to be trivial worries over naming the symbol in fact channel broader concerns over what could be viewed as the spread of Global English that accompany the expanding empires encompassed by American technological services.

With this history put in perspective, one might begin to view the issues surrounding computing culture not as radically new but

as continuous with recurring anxieties we can locate across multiple histories of new media that settle into standardized procedures as technologies become more everyday and less "new." In this frame, the octothorpe/number sign/hashmark, like the period and parenthesis before it, becomes an instructive reading lens, which—as media historical text that is semiotically loose enough to be redefined with new technologies—is synechdochical. That is to say, it both ontologically shifts on a textual level and is also representative of much larger shifts under way in operating systems, media ecologies, and visual culture.

The Human behind the Number: *I Love Alaska,* Search Logic, and Narrative Desire

In keeping with the spirit of this book's inquiry into the cultural logic of punctuation, which turns our attention not only to the ways marks circulate and indeed pervade visual culture, but to the ways thinking associated with these marks also circulates more broadly across media and culture—thus suggesting an even greater pervasiveness of punctuational logics and aesthetics—I conclude this chapter with an analysis of a text, *I Love Alaska,* which triangulates other technological iterations of the symbol, synthesizes its cultural logic, and in the process also returns us to the question of the broader status of semiotics in the digital age.

In particular, this work draws our attention to the # symbol's role as a number sign and how it not only structures information in databases via its role as hashmark but organizes subjects as data bodies in digital ecosystems. The symbol as number sign also closes in on the very idea of the digital as that which is structured by discreet numbers. Isolated, the symbol, not itself a typographical number, helps throw the relationship between punctuation and numbers into relief, inviting one to speculate on the visualization of data in starkly different ways than how this topic is generally broached in digital humanities scholarship.

I Love Alaska is a fifty-minute-long online mini-movie divided into thirteen episodes and was made by Dutch artists Sander Plug and Lernert Engelberts. The movie draws on the residue of an

event in media history: when AOL leaked over 650,000 users'
search histories from a three-month period, which was intended
to be made available for academic researchers but was accidentally
leaked publicly online for three days in August 2006. The film-
makers focus on one user's search history: #711391, identified by
a number sign. The movie features a woman's voice narrating a
selection of the user's search keywords over images of Alaska—
ironically evoking one strand of the search that eventually suggests
the user is planning a family vacation to Alaska. The irony is all
the more biting when juxtaposed with other components of the
user's search history, about marital infidelity, explicitly sexual curi-
osities, celebrity gossip, and anxieties about illness.

The first episode begins with a fast left-to-right swipe of white
text across a black screen, accompanied by a machinic sound that
signifies the presence of an advanced, efficient recording technol-
ogy, that reads: "On August 4, 2006, AOL accidentally published
a text file on its website containing three months' worth of search
keywords submitted by over 650,000 users." After a few seconds,
we then hear wind blowing, sonically bridging the image track's
transition to a shot of Alaska, where the frame of the image is
adjusted and we hear the sound of a computerized surveillance sys-
tem accompanying the adjustment, giving the viewer the feeling
of approaching the film from the perspective of spies, zeroing in
on our target. After we settle on an image of a snowy mountain,
the film presents us with another textual swipe: "The keywords in
this file were typed into AOL's search engine by users who never
suspected that their private queries would be revealed to the public."
We return to our positions as voyeurs, looking at a snowy landscape,
and the film plays with the image's brightness. Another textual
swipe: "After three days, AOL pulled the file from public access, but
not before it had been copied widely on the Internet." Another
image adjustment of a scene in Alaska, and then we see: "This movie
presents the true and heartbreaking search history of user #711391."
The title credits then come on the screen; we are informed that
this is Episode 1, dated March 1–7, 2006, and a final textual swipe
reads: "Introducing user #711391 and her unique way of searching
the Internet." We then cut to what looks like a curtain being lifted

from a window, accompanied by an exaggerated sound effect of the curtain being lifted, revealing a scenic view of Alaska, with mountains in the background and pine trees surrounding tiny buildings in the foreground. We hear a bell ding, white text in the lower left of the frame reveals that this is Wednesday, March 1, 2006, and over the still image we hear a woman's voice: "Cannot sleep with snoring husband." A few seconds later, "How to sleep with snoring husband." We hear a dog barking in the background. "How to kill mockingbirds." "How to kill annoying birds in your yards." We hear a bird sound. "Online friendships can be very special." Another ding, and then we move on to the next day's searches.

Some other queries eventually revealed include the following:

"adults with nervous tic,"

"gay churches in houston tx,"

"pimple that gets white head on it and never goes away,"

"how many online romances lead to sex in person,"

"things for kids to do in alaska,"

"how can you tell if he used you for sex,"

"christian women caught in extramarital affairs,"

"poems about friendship,"

"adults with nervous tic,"

"how does a person get over internet addiction," and

"nicole richie is a bitch."

The filmmakers' project raises ethical questions that, in light of subsequent events—from WikiLeaks' unveiling the contents of diplomatic cables in 2010 to Eric Snowden's release of documents revealing the National Security Agency's massive surveillance programs in 2013—are increasingly pertinent in culture today about access to information, privacy, security, and the Internet. When the AOL leak occurred, many researchers felt that using the leaked

information violated their ethical commitments. Jon Kleinberg, a computer scientist at Cornell, stated in response to the leak, "The number of things it reveals about individual people seems too much. In general, you don't want to do research on tainted data."[20] Christopher Manning, a computer scientist and linguist at Stanford, felt that the possible advantages to using the information for research outweighed the ethical stance that it should not be treated as a valid data set. Despite acknowledging "genuine privacy concerns," he believed that "having the AOL data available is a great boon for research."[21] Through its own artistic entry point to and reliance on this leaked data, *I Love Alaska* provocatively refracts this ethical conundrum, obliging its spectator to consider the extent to which the filmmakers themselves are complicit with AOL's breach of privacy and engage in an ethically inappropriate act. An unavoidable question that *I Love Alaska* raises, in other words, is whether it is an ethically sound documentary project. Without any metacommentary, is it able to pass as a critique of AOL? Do the filmmakers violate the user's right to privacy and intimacy by drawing attention to her search history? Or, viewed from a more redemptive perspective, could *I Love Alaska* be interpreted to function as a critique of the very ideology of privacy—that our data belongs to us?

Twitter and the AOL search leak temporally coevolved: Twitter launched in July 2006, AOL's search leak occurred one month later in August, Chris Messina introduced the # sign on Twitter in 2007, and *I Love Alaska* was completed by 2009. The two phenomena, I would argue, are part and parcel of a broader cultural "hash logic" of searchability and distributability, of hoping that the answers to our questions can be both archived and provided by outsourcing our uncertainties to networked computing machines. *I Love Alaska*'s textual dynamics seemingly strictly adhere to data and, by extension, legitimate its truth claims. Significantly, the movie's protagonist is identified as "#711391." This identification by number sign speaks to the film's larger relationship to fact, giving the impression that the filmmakers are simply relaying content from a database, without veering into subjective interpretation. Along with the numbers provided by the movie's reliance on episodic divisions by weeks and individual sequences by date, the number sign evokes

a sense of mathematical precision and historical accuracy; semiotically speaking, it carries what Roland Barthes might have called the "dream of scientificity."[22] The character indicates also semianonymity: it is a precise identification number belonging to and serving to identify only one person as a highly specific data-collecting and -generating body yet at the same time renders the person unnamed, faceless, and dehumanized.

In this sense, *I Love Alaska* is suggestive of the # sign's allegorical potential for describing the condition of digital culture: as part of a system for organizing, communicating, and differentiating what Helen Nissenbaum refers to as our "personal information flow" in an increasingly networked and information-based society.[23] From this perspective, the sign's function is in fact quite continuous with the hashmark and the telephone's number sign: an iteration for managing information, organizing data. To recall the discussion of the Human Rights Campaign's equal sign in the introduction, on AOL—like so many other contemporary services—we are data bodies, encoded in and represented by mathematical symbols. We are, in short, the digital's digits.

By presenting information contained in leaked search histories, and without relying on extracontextual content, *I Love Alaska* plays with our desire to infer narrative from data. In the first day alone, we encounter an exposition that hints at the protagonist's dissatisfaction with domestic life—bothered by her husband's snoring and birds in the backyard—and curiosity about a virtual life beyond her home that her computer connects her to, with either the possibility of or an already forming "online friendship." As the days proceed, the viewer infers from the data presented a narrative featuring a character we might imagine to be a married, middle-aged, neurotic Christian woman living in Texas who has fantasies of extramarital and alternative forms of sex, and, in the three-month span of the movie's plot, has an affair with someone she meets online and regrets it.

It is instructive to contrast the movie's staging of the desire for narrative and character with a *New York Times* cover story that gives in to it, tracking down a violated woman behind one of AOL's user numbers. Within a few days of the information leak, the newspaper

published a piece on its front page titled "A Face Is Exposed for AOL Searcher No. 4417749." It was accompanied by a photograph, also on the front page, of Thelma Arnold, an older woman with a small black dog standing on her lap and kissing her face, with a caption reading: "Thelma Arnold's identity was betrayed by AOL records for her Web searches, like ones for her dog, Dudley, who clearly has a problem."[24] This caption's joke is a reference to one of Arnold's searches identified in the article for "dog that urinates on everything." This front-page story serves as a counterpoint to *Alaska,* providing the absent "face" behind the semianonymous user number. Even though the *New York Times* piece in a sense reveals *more*—the name and private searches of the user as well—within Helen Nissenbaum's framework of "contextual integrity" for discussing privacy and digital media, it would likely be viewed to be more ethically sound, largely because the piece interviews Arnold and we can therefore presume that she has willingly consented to the information's publication.[25] *I Love Alaska,* on the other hand, offers no such consolation: the woman remains unnamed, and there is no evidence suggesting the user approves of the artistic appropriation of her personal information flow, particularly given its dark, private, and likely embarrassing nature.

A second way to frame the distinction between these two texts is in narrative terms: the *New York Times* story not only offers a character's name and face, but it offers one of the most attractive and necessary features that narrative has to offer: closure. A woman's personal information was wrongly revealed, AOL fixed their mistake, she was identified, she spoke to reporters, and now readers see her dog happily kissing her. By contrast, the movie is steadfastly resistant to cleaning up the messes of digital culture. It confronts its viewers with them—and with a pessimistic paradox. On one hand it stands as a reminder of the public's weak historical memory that new media and its outlets are in the business of making us forget (who recounts or even recalls this search leak anymore?), but at the same time that the event is impossible to remember, it is also impossible to forget. In recirculating leaked data, *I Love Alaska* is suggestive of the historical event's impossibility to achieve closure, drawing on the inevitable residual conse-

Introducing user #711391 and her
unique way of searching the Internet.

Figure 26. *I Love Alaska* (directed by Sander Plug and Lernert Engelberts, 2009)

quences of the AOL leak: though the company removed users' search histories from the Web, that did not stop others, during the three days when the information was publicly available, from downloading and storing the information elsewhere. Years later, #711391's data, along with many other users' search histories, can still be easily accessed.

I Love Alaska could be understood to stage what media theorist Lev Manovich describes as the crucial antagonism between narrative and database, which he claims new media in general throw into relief. He observes that with literature and cinema, "the database of choices from which narrative is constructed (the paradigm) is implicit; while the actual narrative (the syntagm) is explicit. New media reverses this relationship. Database (the paradigm) is given material existence while narrative (the syntagm) is de-materialised. Paradigm is privileged, syntagm is downplayed. Paradigm is real, syntagm is virtual."[26]

What I thus want to suggest is how this movie, digital through and through—from its subject matter to its critique, from its mode

of production to its mode of distribution—might be impossible to fully understand outside of what this chapter has been considering as hash logic. Hash logic is in other words a logic of keywords, searchability, and informaticization; it strips down language to basic elements, to bits of information. From this data, the reader or Internet user is set on a task of inference and filling in gaps, or as Manovich would say, of deducing syntagm from paradigm. A text such as *I Love Alaska,* whose language is reduced to only keywords, precisely through its textual restraint, demonstrates how narrative desire is structurally fetishized by this logic.

At the same time, this movie stages the problematic status of indexicality in the digital age, whereby our access to reality relies less on the presumed authority of the photographic image and increasingly on a presumed authority of the algorithms used to access information. Its content, composed of search terms, not only points to our investment in the belief of a universal index, but, presented in a moving image medium, it also reminds us of indexicality's other side. The identification number points indexically, after all, to a person with thoughts and intentions who exists in the real world. The proof of this reality, however, is not photographic or visual. Indeed, the images of Alaska that the film provides adamantly insist that we are operating outside the logics of visual indexicality. We have no proof that user #711391 ever made it to Alaska with her family. Maybe in the end her extramarital affair destroyed her marriage, or maybe a family vacation to Alaska was just another fantasy she was addicted to imagining, an escape from Texas's stifling heat. Or, maybe user #711391 does not even correspond to a single person, as the movie's narration slyly wants us to believe. In reality, there is a fair possibility that multiple members of the household were sharing one account—hence the range of sexual fantasies explored and also the paranoia not only about cheating but about accessing Internet search histories as well (one query reads, for example, "how can you tell if a spouse has spyware on your computer"). Even if #711391 is a she, and even if she did make it to Alaska, we can rest assured that the film's own images of Alaska do not belong to her.

Without a face behind the user, we are, it would seem, only left with fingertips, if here they are implicit. As a return to Vilém Flusser's poetics, one might sense a series of fingers playing with computers: whether it is AOL user #711391 exploring a new intimacy with her computer or whether it is the filmmakers, ultimately editors, using their fingers manipulatively, to match images with sounds that have no inherent, indexical connection. The false indexicality of the image, in other words, is exposed, while we are confronted with an index of what would seem to be of an altogether different nature. The index as digit as number sign. All conflated by a sort of hash logic into Jimmy Fallon's late night finger-pounding shenanigans.

Emmanuel Levinas's well-known reflections on the face in *Totality and Infinity* are instructive to remember in this context. In a key passage, he writes, "[T]he face speaks to me and thereby invites me to a relation incommensurate with a power exercised, be it enjoyment or knowledge." Levinas suggestively posits the face as a rubric for ethical engagement, using the extreme case of murder as an example: "The epiphany of the face brings forth the possibility of gauging the infinity of the temptation to murder, not only as a temptation to total destruction, but also as the purely ethical impossibility of this temptation and attempt."[27] Another way to make sense of Levinas's point would be to understand the claim as follows: it is when we are face to face with the Other (to hold on to Levinas's terminology) that we are in effect able to determine what our ethical relation to the Other is. In the absence of this face, our ethical compass is tumultuous and less grounded; we are not reminded of the human being for whom our decisions have consequence. This notion hinges on the assumption, as so many writers have claimed in various contexts—to take an example from classical film theory, one might recall Béla Bálazs's writings on the close-up—that the face is an expressive landscape upon which one can read the range of human emotions.[28] Extended into the 2010s, this phenomenon of course surely contributes to Facebook's enormous success as a social networking site: a virtual sea of profile pictures of faces connected to each other, communicating, and sharing information. Levinas's

point also, I would contend, accounts for *I Love Alaska*'s ethical ambiguity: without a face behind the user and only her number, a viewer has difficulty assessing his or her ethical engagement with the text.

In a sense, we return full circle to where this book began: staring into the strange everydayness of the Facebook profile picture, and with a new reading of the equality sign phenomenon. Perhaps it is the massive facelessness this event staged that confronts us with an ethical ambiguity similar to what we find in *I Love Alaska*. Many users of the site believed that uploading an image of an equal sign in the place where they normally show their face was the "right" thing to do, to show their support for marriage equality. But when datasets or typographical characters replace human faces, the effect throws us out of the regime of right and wrong or good and bad— and into a loop of floating signification.

Coda

Canceling the Semiotic Square

The lines that end the preceding chapter were generated when I tried closing the chapter with three consecutive number signs (###), the mark a press release uses to signify the end of the document. The multi-lined graphic Microsoft Word translates them into, like the # signs, also indicates the text has come to a finish. The altered inscription, not what I intended, seems a fitting reminder of how punctuation both signifies on its own and also takes on a command function in digital media contexts—when a specific combination of keys is entered, the computer will turn it into a typographical symbol, lead us to a webpage, or in some other way make a series of complex machinic operations readable for humans.

Upon a first, broad consideration of the semiotics of such inscriptions and transformations, it might seem that we ultimately rearrive at Peirce's basic semiotic rule of the symbol's arbitrary relationship between the signifier and the signified. Especially in looking at the number sign's iterations across media technologies, a striking theme of the previous chapter but indeed of the ones before it as well is that computers are agnostic about which tokens are used to perform which functions. They just need to have functions programmed. One might ask, for example, if the dot in web addresses could have been a comma instead. Yet the same could be asked of natural languages as well—one need only consider that French and English use different marks to signify quotation to see

that marks in a sense are pure symbols—unlike the index and the icon, bearing no trace to their referents. Finally, however, this agnosticism reasserts the importance of the ambiguities and anxieties that humans bring to encounters with technology: the # symbol becomes pure reflection of ideology, from the pervasiveness of hashtags in popular culture to worried reactions about the spread of Global English, from the gendered discourses about the symbol's introduction to telephones to its serving as a visual allegory for the datafication of our lives.

The number sign's function might ultimately be best distilled in an older media history of an inscription the previous chapter did not examine and that is probably less familiar. When a legal document in Ancient Rome was "canceled," one would draw a lattice, crisscrossing lines over the document, effectively and officially deleting the file upon which the mark was superimposed. In her book *Files,* Cornelia Vismann offers a theoretical reading of legal documents as a genre of writing and focuses her first two chapters on canceling, which she argues is a conceptually revealing and sociohistorically constitutive process of writing the law. She explains,

> [T]here is another, far more literal link between barriers and *tabelliones* [Roman notaries]. In the most literal way possible, the latter determine the letter of the law when they use lines and strokes to cross out a draft that has been copied. Because of the "latticed" appearance of the deletions, this act is referred to as "canceling." Derived from Latin *cancelli* grating or lattice, from which are also derived "chancel" and "chancellor"—the word means "to cross out, from crossed lattice lines drawn across a legal document, to annul it, hence destroy or delete it." After they have been copied, drafts must be crossed out so that the clean copy can become the unmistakable original. The act of copying, then, is followed by the act of canceling. Latticed lines or bars exclude the draft from further copying. The lattice covering the writing literally bars textual production; it puts an end to the chancery's babble of voices arising from dictation and public reading, and releases the clean copy, the written law, into a "zone of silence."[1]

Figure 27. "Scripsi." Adriano Capelli, *Lexicon Abbreviaturarum: Dizionario di Abbreviature Latine et Italiane* (Milan, 1994), 411

Vissman argues that this process of deleting "rather than writing establishes the symbolic order of the law."[2] She quotes Derrida, who makes the same point more generally, writing that it is "obliteration that, paradoxically, constitutes the originary legibility of the very thing it erases."[3] *Chancery,* the term for the site where such official documents were written, etymologically comes from *chancel* or *cancel,* "to cross out with lines." The mark's ultimate irony, by extension, is that if the lattice works properly, it obliterates itself. The canceled document disappears. Indeed, in reviewing the various historical trajectories of the # symbol, one could consider how it in effect writes over itself, renamed and reprogrammed again and again. In turn, the cancel figures as a useful metaphor to think about the # symbol's forgotten histories and semiotic circulations—and indeed of the neglected but constitutive legacies and inscriptions of punctuation and typographical symbols more broadly.

This book has staged a series of readings, pausing on moving and still images, revisiting theoretical concepts, and mobilizing them in new directions as inspired by a series of punctuation marks. Rather than following a prescribed path or selectively forcing examples into a predetermined master argument, I have attempted to let the representation and logic of such inscriptions guide our thought to ultimately better make sense of digital media and contemporary culture.

As they move into digital contexts, punctuation marks reveal themselves to be both continuous and discontinuous: each individual mark has a set of relatively dependable qualities and textual functions within its context of use that carries with it an opportunity to reflect on particular cultural protocols, while each mark also

adapts to new conditions of meaning. As such, punctuation's cultural histories and aesthetic practices both direct us to and problematize the categories of "new media" and the "digital": from older moments of new media represented by the number sign's introduction to the touch-tone telephone to the visual culture of dotcommania at the turn of the millennium to the everyday exchanging of emoticons made of punctuation marks in the 2010s. Such textual shifts across contemporary media cultures have largely been critically overlooked, while the little attention that has been paid to various punctuation marks is generally disdainful or at best whimsical. Backlash against the popularity of the hashtag might be the most obvious and recent illustration of this tendency, which itself must be interpreted as having a discursive history rooted in anxieties about language and literacy. Yet the ways in which punctuation marks elicit larger questions about patterns of and within culture, society, art, and knowledge production, I hope to have demonstrated, are suggestive of the ongoing values of critical theories. Theory is needed more than ever at this moment of information overload in our media fields when we are witnessing profound epistemological restructurings that coincide in contemporary scholarly discourses with what often feels like the short-sighted embrace of digital technologies in the hopes that they will solve complicated problems.

On this note, I have in mind a previous remark, written twenty years ago in relation to media theory. W. J. T. Mitchell claimed in 1994, in his introduction to *Picture Theory*: "Knowing what pictures are doing, understanding them, doesn't seem necessary to give us power over them. I'm far from sanguine that this book, or any book, can change the situation. Perhaps its principal function is disillusionment, the opening of a negative critical space that would reveal how little we understand about pictures and how little difference mere 'understanding' alone is likely to make."[4]

Mitchell's "negative critical space" invokes a Nietzschean turn to the dark as forging a path of inquiry, aligning theoretical work with the lucid description of the structures that guide social and cultural practices, so as to cast them in a new light and to reveal the limits of our knowledge, perspectives, and experiences. It is

worth understanding various hesitations to confront the abstract claims of theory in scholarly discourses and research initiatives at the moment in the context of facing what seem to be strikingly "material" problems across the economy and the environment. The more "concrete" nature of digital technologies tempt us with tangible solutions that would seem outside theory's domain. Yet such hope in technology masks conditions whose limits need to be confronted in their own terms. Aren't many "material" problems facing us fundamentally ideological? Haven't the great philosophers compellingly shown how ideological and material conditions, base and superstructure, are mutually constitutive?

I am aligned with efforts by a handful of media scholars, from Wendy Chun to Alexander Galloway to Mark Hansen, who have turned to rather than away from theory to make more complete sense of the cultural implications of digital media, mobilizing concepts that allow us to think through and understand the stakes of the digital within long and deep, or even scattered, philosophical trajectories. I share a realist skepticism with Mitchell, however, about the limits of theoretical work's potentials for enacting substantive change upon its areas of study.

Nonetheless, I hope this book has demonstrated some potentials for renewing rich traditions of theoretical inquiry for digital contexts—specifically, in this case, those associated with semiotics—that have largely been abandoned but are needed for making sense of contemporary textual mobility and visual culture. Punctuation marks are more present than ever in our visual field, engaging in contradictory but nevertheless structuring processes of making meaning.

Pronouncing an even more direct engagement with semiotic theory, this book originally began with an illustration of a semiotic square, which would map out the conceptual relations among the primary symbols that each chapter would proceed to examine. The logic of the semiotic square relies on its most fundamental level on a term and its opposite. As Paul Bouissac explains, the first phase in the "generation of the categorical terms that articulate semantic categories" in the Greimasian square is a "set of relations between a term and its contrary and between these two terms and their

contradictories."[5] Though there have of course been a fair share of very complex semiotic squares drawn by sophisticated thinkers, punctuation marks did not seem to map onto one appropriately. As we have seen, punctuation tends to fall outside the logic of binary suppositions, perhaps most obviously of image/language and of number/letter. Punctuation's ability to flirt with and escape such traditional categories, as implied by Flusser and Barthes, is precisely one of its most alluring features.

It was not until considering how the # symbol leaves us alongside the history of the lattice mark, as Vissman documents it, that, rather than opening the book with a semiotic square, it made sense to instead close the book by "canceling" the semiotic square. How might this ancient hash's tic-tac-toe structure, like the semiotic square, invite us to map conceptual relations by filling in its various coordinates? Reappropriating the Roman lattice as a form in lieu of the square offers the conceptual advantage that it need not be restricted to the binary divisions that so often structure the logic of the square into oppositions. The form of the lattice nevertheless offers a similarly gridded structure, which, like the square, could be used to map out relations with categories, if only as provocations for critical reflection. From the dot to the hash, punctuation today is continually redefined and put to new uses to help navigate and manage textual expression and proliferation. Thus I close with a playful gesture that once again puts a loose punctuational mark to a new use, here becoming a metamark for visualizing conceptual relations among other punctuation marks.

The perfect lattice would, ontologically, never be seen or written in. I will embrace this book's many inevitable imperfections and let the square's cancel remain imperfect by actually drawing a lattice. In other words, I offer a cancel in the form of a semiotic lattice for my readers. Like *Me and You and Everyone We Know*'s parenthetical expression that turns punctuation inside out to allow its young character to charmingly visualize his perverse idea, the following lattice deforms the traditional semiotic square, spilling out into its environment rather than closing itself off from it. I invite you, the reader, to draw in it and use it to visualize the dynamics

Figure 28. Semiotic lattice

of punctuation marks—those that this book has explored and/or those it has left out.

Will you place the marks all in one corner? Will you fill in each grid with a different mark? Do those marks that use the computer's shift key for their inscription go at the top and those that are "unshifted" belong at the bottom? Will "loose" punctuation marks like the hash be separated from "strict" marks like the period? Perhaps one column is for letters, one for numbers, and one for punctuation? Or is the grid itself punctuation, mapping out nonsemantic relations of thought? Does every mark inscribe its own history of erasure? The lattice, in the end, stands as a summary of where this book's winding path into the digital present has taken us.

Notes

Introduction

1 Visual AIDS Staff, "Before There Were Memes, There Was LOVE, AIDS, RIOT," http://www.visualaids.org/blog/detail/7509#.UVn OlXDZYeG (27 March 2013).

2 This line, though, is in fact spoken by Barnes's character Felix, describing his love for Robin, in *Nightwood* (New York: New Directions, 1937), 111.

3 Immanuel Kant, *Prolegomena to Any Future Metaphysics,* trans. Paul Carus (Indianapolis: Hackett, 1977), 14.

4 Naomi Klein, *No Logo* (Toronto: Knopf Canada, 1999), 26.

5 Jean Baudrillard, "The Precession of Simulacra," in B. Wallis, ed , *Art after odernism* (Boston: Godine, 1984).

6 Kathy Giuffre, Interview with Ryan Conrad, *Off Topic,* Episode 4, "Marriage Unions, and The Politics of Partnership" (5 April 2013), http://offtopicradio.org/2013/04/05/episode-4-marriage-unions -and-the-politics- of-partnership/.

7 David Golumbia, *The Cultural Logic of Computation* (Cambridge, Mass.: Harvard University Press, 2009), 14.

8 Fredric Jameson, "Postmodernism, or, The Cultural Logic of Late Capitalism," *New Left Review* I/146 (July–August 1984): 57.

9 Marshall McLuhan, *The Gutenberg Galaxy: The Making of Typographic Man* (Toronto: University of Toronto Press, 1962).

10 Theodor Adorno, "Punctuation Marks," trans. Shierry Weber Nicholsen, *Antioch Review* 48, no. 3, Poetry Today (Summer 1990): 301.

11 Bruno Latour, "Visualisation and Cognition: Drawing Things Together," in *Knowledge and Society: Studies in the Sociology of Culture Past and Present,* vol. 6, ed. H. Kuklick (Bingley, UK: Jai Press, 1986), 7.

12 M. B. Parkes, *Pause and Effect: An Introduction to the History of Punctuation in the West* (Berkeley: University of California Press, 1993), 1.

13 Adorno, "Punctuation Marks," 300–301.

14 Jodi Dean, *Blog Theory: Feedback and Capture in the Circuits of Drive* (Cambridge, UK: Polity, 2010), 1.

15 Wendy Hui Kyong Chun, "The Enduring Ephemeral, or the Future Is a Memory," *Critical Inquiry* 35, no. 1 (Autumn 2008): 148–71.

16 Michael Fried, "Barthes's *Punctum,*" *Critical Inquiry* 31, no. 2 (Spring 2005): 542.

17 Roland Barthes, *Camera Lucida: Reflections on Photography,* trans. Richard Howard (New York, NY: Hill and Wang, 1981), 8.

18 Ibid., 26.

19 Ibid., 26–27.

20 Fried, "Barthes's *Punctum,*" 546.

21 Barthes, *Camera Lucida*, 8.

22 Vilém Flusser, *Does Writing Have a Future?,* trans. Nancy Ann Roth (Minneapolis: University of Minnesota Press, 2011), 20.

23 Ibid., 25.

24 Ibid., 23.

25 Johanna Drucker, *The Alphabetic Labyrinth: The Letters in History and the Imagination* (London: Thames and Hudson, 1995), 21.

26 W. J. T. Mitchell, "The Pictorial Turn," *Artforum International* 30, no. 7 (March 1992): 89–94.

27 Jennifer Devere-Brody, *Punctuation: Art, Politics, and Play* (Durham, N.C.: Duke University Press, 2008), 48, 165.

28 Jonathan Crary, *24/7: Late Capitalism and the Ends of Sleep* (London: Verso, 2013), 44.

29 Quoted in Calvin Tomkins, "Experimental People," *The New Yorker* 90, no. 5 (24 March 2014): 38.

30 Brian Droitcour, "Making Word: Ryan Trecartin as Poet," *Rhizome* (27 July 2011), http://rhizome.org/editorial/2011/jul/27/making-word-ryan-trecartin-poet/.

31 Allegra Krasznekewicz, "Ryan Trecartin at LACMA," *Daily Serving: An International Publication for Contemporary Art* (31 March 2014).

32 Droitcour, "Making Word."

33 Piper Marshall, "Hash the Planet," *Artforum* (2 September 2011), http://artforum.com/diary/id=28881.

34 Lisa Samuels and Jerome McGann, "Deformance and Interpretation," *New Literary History* 30, no. 1 (1999): 26.

35 Susan Sontag, "Against Interpretation," *Against Interpretation and Other Essays* (New York: Picador, 2001), 4.

36 Parkes, *Pause and Effect,* 1.

37 Lynne Truss, *Eats, Shoots & Leaves: The Zero Tolerance Approach to Punctuation* (New York: Gotham Books, 2003).

38 See, for example, André Bazin's "The Myth of Total Cinema" or "The Evolution of the Language of Cinema," in *What Is Cinema? Vol. 1,* trans. Hugh Gray (Berkeley: University of California Press, 1967), 17–40.

39 A useful overview of literary codework that is quite attuned to the genre's tendency for punctuational play is Rita Raley's "Interferences: [Net.Writing] and the Practice of Codework," *electronic book review* (September 2002).

40 Michel Gondry interviewed by Adam Schartoff, *Filmwax Radio,* episode 177 (25 November 2013), http://rooftopfilms.com/blog/.

1. Connecting the Dots: Periodizing the Digital

1 Paul A. David, "Clio and the Economics of QWERTY," *American Economic Review* 75, no. 2 (May 1985): 333.

2 Tim O'Reilly, "What Is Web 2.0? Design Patterns and Business Models for the Next Generation of Software," in *The Social Media*

Reader, ed. Michael Mandiberg (New York: New York University Press, 2012), 32.

3 Ben Yagoda, "The Point of Exclamation," *New York Times* (6 August 2012).

4 Ben Crair, "The Period Is Pissed," *New Republic* (25 November 2013), http://www.newrepublic.com/article/115726/period-our-simplest -punctuation-mark-has-become-sign-anger.

5 N. Katherine Hayles, *My Mother Was a Computer: Digital Subjects and Literary Texts* (Chicago: University of Chicago Press, 2005), 39.

6 Ashley Kunsa writes, "F. Scott Fitzgerald once called for authors to 'Cut out all these exclamation points,' claiming, 'An exclamation point is like laughing at your own joke.'" She likens Fitzgerald to Cormac McCarthy, who in an interview with Oprah Winfrey dismissively referred to punctuation as "weird little marks." Kunsa, "Mystery and Possibility in Cormac McCarthy," *Journal of Modern Literature* 35, no. 2 (2010): 146. See also http://excessiveexclamation. blogspot.ca/.

7 David Shipley and Will Schwalbe, *Send: Why People Email So Badly and How to Do It Better* (New York: Alfred A. Knopf, 2008), 137.

8 Jen Doll, "The Imagined Lives of Punctuation Marks," *Atlantic Wire* (21 August 2012).

9 Carol E. Lee, "Punctuation Nerds Stopped by Obama Slogan, 'Forward.'" *Wall Street Journal* (30 July 2012).

10 Victor Morton, "New Obama Slogan Has Long Ties to Marxism, Socialism," *Washington Times* (30 April 2012).

11 Alexander Galloway, *Protocol: How Control Exists after Decentralization* (Cambridge, Mass.: MIT Press, 2004), 8.

12 J. Postel and J. Reynolds, "Domain Requirements," RFC 920 (October 1984), 1.

13 P. Mockapetris, "Domain Names–Concepts and Facilities," RFC 1034 (November 1987), 1.

14 Paul Garrin, "DNS: Long Winded and Short Sighted," *Nettime* (19 October 1998).

15 Mockapetris, "RFC 1034," 8.

16 Katie Hefner and Matthew Lyon, *Where Wizards Stay Up Late: The Origins of the Internet* (New York: Simon and Schuster, 1996), 144.

17 Brian Reid, quoted in Hefner and Lyon, *Where Wizards Stay Up Late,* 144.

18 Walter Ong, "Historical Backgrounds of Elizabethan and Jacobean Punctuation Theory," *PMLA* 59, no. 2 (June 1944): 353.

19 J. Postel, IEN 161 (August 1979), 1.

20 Ong, "Historical Backgrounds," 351.

21 David Denby, "Adaptation," *The New Yorker* (9 December 2002).

22 Joshua Landy, "Still Life in a Narrative Age: Charlie Kaufman's *Adaptation,*" *Critical Inquiry* 37, no. 3 (Spring 2011): 508–9.

23 Andrew Ross, *No Collar: The Humane Workplace and Its Hidden Costs* (New York: Basic Books, 2003), 14.

24 Geert Lovink, "After the Dotcom Crash: Recent Literature on Internet Business and Society," *Australian Humanities Review* (September 2002).

25 Gina Neff, *Venture Labor: Work and the Burden of Risk in Innovative Industries* (Cambridge, Mass.: MIT Press, 2012), 6.

26 Walter Benjamin, "Theses on the Philosophy of History," in *Illuminations,* ed. Hannah Arendt, trans. Harry Zohn (New York: Schocken Books, 1968), 257.

27 Charlie Kaufman, *Adaptation.,* November 21, 2000 revision, 76.

28 Marjorie Garber, *Quotation Marks* (New York: Routledge, 2003), 5.

29 Benedetto Croce, *History: Its Theory and Practice,* trans. Douglas Ainslie (New York: Russell and Russell, 1960), 12.

30 Marshall Brown, "Periods and Resistances," *Modern Language Quarterly* 62, no. 3 (December 2001): 312.

31 David Perkins, *Is Literary History Possible?* (Baltimore, Md.: Johns Hopkins University Press, 1992), 64.

32 Fredric Jameson, "Periodizing the 60s," *Social Text* 9/10 (Spring/Summer 1984): 178.

33 Brian Rotman, *Becoming Beside Ourselves: The Alphabet, Ghosts, and*

Distributed Human Being (Durham, N.C.: Duke University Press, 2008); Hayles, *My Mother Was a Computer.*

34 Rotman, *Becoming Beside Ourselves,* 2.

35 N. Katherine Hayles, *How We Think: Digital Media and Contemporary Technogenesis* (Chicago: University of Chicago Press, 2012).

36 Peter Sloterdijk, *Spheres, Vol. 1: Microspherology*, trans. Wieland Hoban (Los Angeles, Calif.: Semiotext(e), 2011).

37 Ibid., 80–81.

38 Timothy Morton, *Hyperobjects: Philosophy and Ecology after the End of the World* (Minneapolis: University of Minnesota Press, 2013).

39 Hayles, *How We Think,* 55–79.

2. Within, Aside, and Too Much: On Parentheticality across Media

1 Alan Liu, *The Laws of Cool: Knowledge Work and the Culture of Information* (Chicago: University of Chicago Press, 2004).

2 Duncan White, "'(I have camouflaged everything, my love)': *Lolita*'s Pregnant Parentheses," *Nabokov Studies* 9 (2005): 48.

3 Jacques Derrida, "Signature Event Context," *Limited Inc* (Evanston, Ill.: Northwestern University Press, 1988), 1–21. The irony is not lost that this essay was, in fact, originally delivered not in print, but in an oral presentation.

4 Ibid., 2.

5 Ibid., 21.

6 Derrida's idea of "non-saturation" is essentially related to his idea of there always being an act of absent reading that is present in every act of writing. One can never know what traveling a piece of writing will do, and this uncertainty is always necessarily worked into the act of writing, and it is this sort of openness to uncertain futures, meanings, and paths that marks context as non-saturated—never finished, never completely mastered. "Signature Event Context," 3–12.

7 Theodor W. Adorno, "Punctuation Marks," trans. Shierry Weber Nicholsen, *The Antioch Review* 48, no. 3 (Summer 1990): 304.

8 Robert Grant Williams, "Reading the Parenthesis," *SubStance* 22, no. 1 (1993): 53.

9 Roger Ebert, "500 Days of Summer," *Chicago Sun Times* (15 July 2009).

10 Joseph Natoli, "The Perils of Being *Up in the Air*," *Senses of Cinema* (April 2010), http://sensesofcinema.com/2010/feature-articles/the -perils-of-being-up-in-the-air/.

11 Michel Foucault, *The History of Sexuality*, trans. Robert Hurley (New York: Pantheon Books, 1978), 27.

12 Friedrich Nietzsche, *On the Genealogy of Morals and Ecce Homo*, ed. and trans. Walter Kaufmann (New York: Vintage Press, 1989), 97–98.

13 Quoted in *Derrida* (directed by Kirby Dick and Amy Ziering, U.S., 2002).

14 Rose Goldsen, *The Show and Tell Machine: How Television Works and Works You Over* (New York: Dial Press, 1977), 67.

15 These are examples of phrases Goldsen uses elsewhere in the chapter to describe the range of sounds the laff box can make. Ibid., 68.

16 Rick Altman, *The American Film Musical* (Bloomington: Indiana University Press, 1987), 202.

17 The laugh track has also captured the theoretical interest of Slavoj Zizek. He has written of it in terms of its setting into place not interactivity, but an "interpassive" engagement, by which the laugh track "deprives" us of our own "passive reaction of satisfaction." He uses this notion to suggest that contrary to the more traditional criticism of new media, they turn us into passive consumers: "the real threat of new media is that they deprive us of our passivity, of our authentic passive experience, and thus prepare us for mindless frenetic activity—for endless work." In "Will You Laugh for Me, Please?" 18 July 2003, http://www.16beavergroup.org/mtarchive/archives /000330.php.

18 *Gelbart Papers*, Box 36, Folder 5, 2. UCLA special collections, Performing Arts. The "strikethrough" font stands for what was crossed out in pencil in the manuscript. Apparently, in fact, the network did do "testing" of the show with and without the laugh track. Todd Gitlin writes, "After a few years of its run, . . . the producers of *M*A*S*H* tried to convince CBS to drop the show's laugh track, which they thought distracting. Testing showed that the same show scored higher with the track than without it, so the track stayed," *Inside Prime Time* (New York: Pantheon Books, 1983), 33. Gitlin notes

in his own footnote to this that the British syndication of *M*A*S*H* did not employ a laugh track. He comments that Americans require "social cues to confirm what is comical," further reflecting the sort of disdain with which scholars and television watchers regard the track.

19 Suzy Kalter, *The Complete Book of M*A*S*H* (New York: H. N. Abrams, 1984), 29.

20 There have also been numerous social psychology experiments conducted that examine the relationships between perceptions of humor, self-perception, and gender differences that use the laugh track as a variable. See, for instance, Howard Leventhal and Gerald C. Cupchik, "The Informational and Facilitative Effects of an Audience upon Expression and the Evaluation of Humorous Stimuli," *Journal of Experimental Social Psychology* 11 (1975): 363–80.

21 Williams, "Reading the Parenthesis," 53.

22 Jacob Smith, "The Frenzy of the Audible: Pleasure, Authenticity, and Recorded Laughter," *Television and New Media* 6, no. 3 (2005): 23.

23 Many live–audience laughs for laugh tracks were recorded from pantomime routines such as Red Skelton's, since the silence of the performance makes it easier to record pure audience sound. Ben Glenn II, "A Short History of the Laugh Track," www.tvparty.com/laugh.html.

24 Lisa Gitelman, *Always Already New: Media, History and the Data of Culture* (Cambridge, Mass.: MIT Press, 2005).

25 Derrida, "Signature Event Context," 2.

26 Julia Bryan-Wilson, "Some Kind of Grace: An Interview with Miranda July," *Camera Obscura* 19, no. 1 (2004): 193.

27 Carina Chocano, "Me and You and Everyone We Know," *Los Angeles Times* (24 June 2005).

28 Laura Mulvey, "Visual Pleasure and Narrative Cinema," *Screen* 16, no. 3: 6–18.

29 Foucault, *History of Sexuality,* 11.

30 Charlie Chan, "Back and forth, forever," *Me and You and Everyone We Know,* IMDb user comment board, page 1, http://imdb.com/title/tt0415978/usercomments (posted 3 May 2005).

31 David Bordwell, "Mutual Friends and Chronologies of Chance," in *Poetics of Cinema* (New York: Routledge, 2008), 189–250. Bordwell discusses *Me and You* throughout the chapter and in detail on 216–17.

32 Fredric Jameson, *Postmodernism, or, the Cultural Logic of Late Capitalism* (Durham, N.C.: Duke University Press, 1991), 4.

33 Rosalind Krauss, "Video: The Aesthetics of Narcissism," *October* 1 (Spring 1976); Jean Baudrillard, *The System of Objects*, trans. James Benedict (London: Verso, 2005), 70. Krauss writes, "Unlike the other visual arts, video is capable of recording and transmitting at the same time—producing instant feedback. The body is therefore as it were centered between two machines that are the opening and closing of a parenthesis. The first of these is the camera; the second is the monitor, which re-projects the performer's image with the immediacy of the mirror" (52). She later elaborates on this "paradigm situation" in relation to *Vertical Roll* (61). Video's medium-specific instant feedback could be read as instantiating a trajectory of a distinctly postmodern aesthetic that undoes the unidirectional, top-down path from artist to spectator, which continues to be relevant with online video, Web 2.0, and user-generated content.

34 Jean-Louis Baudry, "Ideological Effects of the Basic Cinematographic Apparatus," Critical Visions in Film Theory: Classic and Contemporary Readings, ed. Timothy Corrigan, Patricia White, and Meta Mazaj (Boston, MA: Bedford/St. Martin's, 2011), 40.

35 Bruno Latour, "Why Has Critique Run Out of Steam? From Matters of Fact to Matters of Concern," *Critical Inquiry* 30 (Winter 2004): 236.

36 Bruno Latour, *We Have Never Been Modern* (Cambridge, Mass.: Harvard University Press, 1993).

3. # Logic

1 Susan Orlean, "Hash," *New Yorker Online* (June 2010), http://www.newyorker.com/online/blogs/susanorlean/.

2 Lindy West, "Symbol of the Year: #," *GQ.com* (13 December 2010).

3 Kelly Conniff, "France Bids Adieu to the Word 'Hashtag,'" *Time* (30 January 2013).

4 Marquard Smith, "Theses on the Philosophy of History: The Word

of Research in the Age of Digital Searchability and Distributability," *Journal of Visual Culture* 12, no. 3 (2013): 385.

5 Piper Marshall, "Hash the Planet," *Artforum* (2 September 2011), http://artforum.com/diary/id=28881.

6 Marjorie Garber, *Quotation Marks* (New York: Routledge, 2003), 10.

7 Wendy Chun, "The Enduring Ephemeral, or the Future Is a Memory," *Critical Inquiry* 35, no. 1 (Autumn 2008): 148–71.

8 M. B. Parkes, *Pause and Effect: An Introduction to the History of Punctuation in the West* (Berkeley: University of California Press, 1993), 10, 11.

9 Espen Aarseth, *Cybertext: Perspectives on Ergodic Literature* (Baltimore, Md.: Johns Hopkins University Press, 1997), 40.

10 N. Katherine Hayles, "Print Is Flat, Code Is Deep: The Importance of Media-Specific Analysis," *Poetics Today* 25, no. 1 (Spring 2004): 67–90.

11 Alexander Galloway, "Language Wants to Be Overlooked," *Journal of Visual Culture* 5, no. 3 (December 2006): 320–21.

12 Bernard Stiegler, *Technics and Time: 2,* trans. Stephen Barker (Stanford, CA: Stanford University Press, 2009), 98, 116, 136.

13 Vilém Flusser, "The Non-Thing 2," in *The Shape of Things,* trans. Anthony Mathews (London: Reaktion, 1999), 92.

14 "A Story About '#'," Western Electric news features (September 1973), courtesy of AT&T.

15 "New Phone Buttons Offer Instant Banking, Cooking," *Bell Labs News* (29 March 1968).

16 Sadie Plant, *Zeroes + Ones: Digital Women + The New Technoculture* (New York: Doubleday, 1997); Alexander Galloway, *Protocol: How Control Exists after Decentralization* (Cambridge, Mass.: MIT Press, 2004), 188; Wendy Chun, *Programmed Visions: Software and Memory* (Cambridge, Mass.: MIT Press, 2011), 29–34.

17 James R. Harris, letter to William Safire (25 March 1991), courtesy of AT&T Archives, 1.

18 Ibid., 2–3.

19 "A Story about '#'," Western Electric news features (September 1973), courtesy of AT&T.

20 Katie Hafner, "Researchers Yearn to Use AOL Logs, but They Hesitate," *New York Times* (23 August 2006).

21 Ibid.

22 Roland Barthes, "Réponses" (interview), *Tel Quel* 47 (Autumn 1971): 97.

23 Helen Nissenbaum, *Privacy in Context: Technology, Policy, and the Integrity of Social Life* (Stanford, Calif.: Stanford University Press, 2010), 4.

24 Michael Barbaro and Tem Zeller Jr., "A Face Is Exposed for AOL Searcher No. 4417749," *New York Times* (9 August 2006).

25 Nissenbaum, *Privacy in Context*, 6–11.

26 Lev Manovich, "Database as a Symbolic Form," *Convergence* 5 (1999): 89.

27 Emmanuel Levinas, *Totality and Infinity: An Essay on Exteriority*, trans. Alphonso Lingis (The Hague: Martinus Nijhoff Publishers, 1979), 198, 199.

28 See Mary Ann Doane's overview of these discourses in her essay "The Close-Up: Scale and Detail in Cinema," *differences: A Journal of Feminist Cultural Studies* 14, no. 3 (Fall 2003): 89–111.

Coda

1 Cornelia Vismann, *Files: Law and Media Technology*, trans. Geoffrey Winthrop-Young (Stanford, Calif.: Stanford University Press, 2008), 26.

2 Ibid.

3 Jacques Derrida, *Of Grammatology*, trans. Gayatri Spivak (Baltimore, Md.: Johns Hopkins University Press, 1997), 109, quoted in Vissman, *Files*, 26–27.

4 W. J. T. Mitchell, *Picture Theory: Essays on Verbal and Visual Representation* (Chicago: University of Chicago Press, 1994), 6.

5 Paul Bouissac, *Encyclopedia of Semiotics*, ed. Paul Bouissac (Oxford: Oxford University Press, 1998), 866.

Index

Jeff Scheible is assistant professor of cinema studies at Purchase College, State University of New York.